How to Make Your Own
PICTURE FRAMES

Third Edition, Completely Revised and Enlarged

How to Make Your Own PICTURE FRAMES

By Hal Rogers and Ed Reinhardt

WATSON-GUPTILL PUBLICATIONS/NEW YORK

Paperback Edition
First Printing 1989

Copyright © 1958, 1981, by Harold L. Rogers and Edwin P. Reinhardt

First published in 1981 in the United States and Canada by Watson-Guptill
Publications, a division of Billboard Publications, Inc.,
1515 Broadway, New York, N.Y. 10036

Library of Congress Catalog Card Number: 81-11536

ISBN 0-8230-2451-2
ISBN 0-8230-2452-0 pbk.

Distributed in the United Kingdom by Phaidon Press Ltd.,
Musterlin House, Jordan Hill Road, Oxford OX2 8DP

Manufactured in U.S.A.

1 2 3 4 5 6/93 92 91 90 89

To Chrissy Rogers and Anneke Reinhardt

Acknowledgments

Our thanks to Stanley Tools of New Britain, Connecticut, and to the Pootatuck Corporation of Windsor, Vermont, for their assistance and cooperation in choosing tools.

And to Leonard Frehm, some of whose work we show as examples of tasteful and original framing made from carpenter's moldings.

Photography by Zoltan Henczel.

Contents

Introduction

Albert Dorne, famous American artist and entrepreneur, wrote this introduction when How to Make Your Own Picture Frames *was first published in 1958. His words are as fitting today as then. Only Hal's and Ed's biographies need updating. Ed is now heading his own design firm in Hollywood, Florida. Hal is chairman and head art director in his own advertising agency, Shailer Davidoff Rogers, Inc. in Fairfield, Connecticut.*

Hal Rogers and Ed Reinhardt are eminently qualified experts on picture-framing—both from the craftsman's standpoint—they have been making their own handsome frames for years—and from the æsthetic standpoint—both are accomplished professional artists.

Hal Rogers joined the Royal Canadian Air Force shortly before Pearl Harbor, and was eventually placed in charge of an R.C.A.F. Art Department in Ottawa. After the war, he studied at Pratt Institute, free-lanced, and worked as Assistant Art Director for an advertising agency. After several years as Art Director for American Management Association, he joined the Famous Artists School in Westport, Connecticut, where he was responsible for the design and art direction of all printed matter in this country and Europe. In his spare time, he enjoys Fine Art painting. All of his experience has been in the visual field—the business of picture making. Many years ago, he became interested in picture framing as one method of making a good picture look even better.

Ed Reinhardt spent his early years roaming around the world as a seaman, cook and ship-rigger. During World War II he served in three branches of the service—the Merchant Marine, the Navy and the Army Air Force. In the Air Force, he ran Training Aids Departments which led to his being hired in a civilian capacity, upon discharge, to continue in research and development of visual teaching aids and methods.

"All this time," he says, "I had been fitting painting into a way of life. In 1950, I decided the cart was before the horse and since then I have devoted full time to painting."

He spent two and a half years in Florida, studying and teaching. During this time his paintings were exhibited in museums and galleries throughout the South . . . and he began to be actively interested in finding ways to make good frames inexpensively. Experimentation and experience led to the underlying principle of this book.

From Florida, Ed came north and joined the staff of the Famous Artists School as an instructor of painting. There, he met Hal Rogers, and the two pooled their knowledge and experience to produce this book.

The step-by-step demonstrations in this excellent do-it-yourself book are remarkably simple. Its unique format, and the ease with which it can be used as a simple "working blueprint" make it foolproof for the absolute amateur or skilled professional to produce his own fine frames. The pleasure and satisfaction of making the right frame for the right picture at no more than the cost of the raw materials make this book a must for every artist.

Albert Dorne
Founder
Famous Artists School

MAKING YOUR OWN FRAMES

The Right Frame

By today's standards a room is not completely decorated until at least one picture is hung on the wall. The tremendous increase in the number of people studying art, the sale of prints and originals—even the popularity of the do-it-yourself picture kits—all confirm the fact that people today want pictures to live with.

What makes a good picture we leave to the taste and choice of the reader. One thing is certain, however: even an original painting worth thousands of dollars will lose value if it is badly framed. On the other hand, a print worth only pennies can look smashing and be the source of lifelong enjoyment if it is properly framed. In short, the final effect of any picture depends on the taste, proportion and craftsmanship of its frame. The right frame will enhance the presentation of any picture.

Finding the "right" frame has always been a problem. When they are to be found, their cost is often prohibitive. Whether one is a professional artist whose frame bills are a constantly recurring expense or a person with one print to frame, availability and cost are the two major considerations.

Precut frames and frame kits are available in large department stores, by mail order, and in many of the do-it-yourself lumber yards. These are precut, prefinished, preassembled, and are simple to put together. However, they are not cheap and they are usually only available in standard sizes, which means that in many cases your picture, print, photo, or mat will be limited to the manufacturer's standard measurements. He also dictates the molding design and finish.

Now if you have lots of money and/or only one or two things to frame, a trip to your nearest framer or through the Yellow Pages to one of the "you-frame-it" stores may be all you need. But what if you paint or take your own pictures, cropped to the exact proportions you want? What if you know *exactly* the character you want the frame to have, *exactly* the texture and color of the finish? Or what if you don't want to spend a lot?

The simplest solution is of course to make your own frames. The raw materials demonstrated in this book are relatively inexpensive, and a frame is after all only four sticks joined together. Yet if you talk to any amateur who has tried to build a frame you will most likely encounter a long tale about the numerous pitfalls and frustrations lying in wait for the unsuspecting neophyte.

Fortunately this need not be so. This book will provide you with a thorough basic knowledge of how to make and finish your own picture frames simply and at moderate cost from materials that are readily available.

About This Book

Before we consider the actual work, a word is necessary to those about to set up shop. A great deal of useless expense can be avoided if you define your aims first. Do you have one picture to frame? A dozen? Are you planning to make frames regularly? Read the discussions of tools, materials, and moldings before you begin purchasing. You may find that you already have many of the things you need; if not, the text will provide a guide for finding the tools and materials that best fit your budget and degree of interest.

Throughout the book we emphasize a professional approach utilizing modern materials and methods that we have found through experience to be sound. We believe that excellence need not be predicated upon complexity; therefore we have avoided the specialized formulas and cookery often associated with frame making and finishing and in their place show you practical, uncomplicated ways and means to achieve exceptional results.

The book itself is designed for your workbench rather than your bookshelf. Cross references have been kept at an absolute minimum, and the convenience and usefulness further increased by grouping all the construction demonstrations in the one section and all the mounting and finishing operations in another.

Although creative picture framing has a long way to go to catch up with the advances that have been made in other artistic fields, new products are constantly being introduced. We suggest that you keep your eyes open for new materials that may be applicable to framing, though not necessarily marketed for that purpose. While we know our book will give you the firm understanding needed to make good frames, we present it mainly in the hope that it will stimulate your imagination and make you aware of the limitless possibilities

that today's new materials and contemporary tastes bring to this traditional art.

How to Begin

Good taste is always a paramount concern in framing any picture. Yet it is obvious that the most tasteful frame won't last long if it is poorly constructed. As with any undertaking, acquiring facility and skill in framing takes time and experience. Each framing problem or technique you master will give you confidence and make the next challenge that much easier to meet. The time you spend developing your craftsmanship in the early stages will be rewarded by increased skill and capability later on. Better-looking, longer-lasting frames take only a little longer to make than mediocre ones.

Starting on page 24, we show you how to build a frame that involves all of the fundamental construction problems you are likely to come up against. Because we all learn best by experiencing things for ourselves, we recommend that you follow the steps of the demonstration and build this first frame.

You will begin by cutting simple 90° corners in the rabbet strip. These butt joints are the easiest type to cut in a miter box. Your introduction to the 45° miter cut takes place rather painlessly on the relatively narrow insert molding. From here it is an easy step to cutting the miters in the wider drip cap molding and finally to mitering the 4-inch-wide (10 cm) backing.

Joining and assembling operations are outlined in the same logical progression, beginning with the simplest joint and proceeding step by step to the final assembly.

In addition to gaining familiarity with your tools and confidence in your ability, you will be doubly pleased to find that the simple lines of your first frame will complement a great many paintings and drawings.

What About Tools?

In setting up your shop the biggest item in your budget will be your equipment. A good deal of thought should be given to the selection of just the right tool for each job.

When you get to your hardware store and are confronted by hundreds of tools in every conceivable price range, the main factors to consider in judging which ones to buy are the use you are going to give them, the quality, and the cost. It would be silly for instance to buy a $75 miter box to make a single frame. On the other hand, if you are going to make frames with any regularity a $10 miter box would be just as ridiculous a purchase. Choose the tools that best fit the program you have set for yourself.

Generally speaking, you will never go wrong choosing the tool of better quality over the cheaper one. Quality tools are more efficient, do a better job more easily, and will be more economical in the long run. In addition to being less proficient, cheaper tools will need replacement more often. Read the following detailed discussions of each tool and then talk over your aims with your hardware dealer; he will be glad to help you make the best possible choice.

Workbench. The efficiency of your workbench can go a long way toward helping you do a better job more easily. It should be sturdy enough to withstand hammering and sawing, and its surface should be level for easy frame assembly, mat cutting, glass cutting, and so on. For comfort while you are working and depending on your height, it should be about 36 inches (91 cm) high and large enough to accommodate any frame you are building.

Since it is easier to work around a frame than to shift the frame during construction or finishing, you will want to be able to reach your bench from all sides. Place the bench away from the wall, and if possible fasten it to the floor for added rigidity.

Because of our photographic requirements for this book, we have used a drawing table as our workbench. While we don't advise it as a permanent solution, the occasional framer might examine its possibilities as a quick means of turning a corner of the studio into a temporary frame shop.

Miter box. We were amazed at the variety of miter boxes being offered by hardware stores and building supply centers today. Though we've shown only a few here, it will really pay you to shop around because together with the backsaw, the miter box is the nucleus of any framing operation. Of all the items you purchase, the

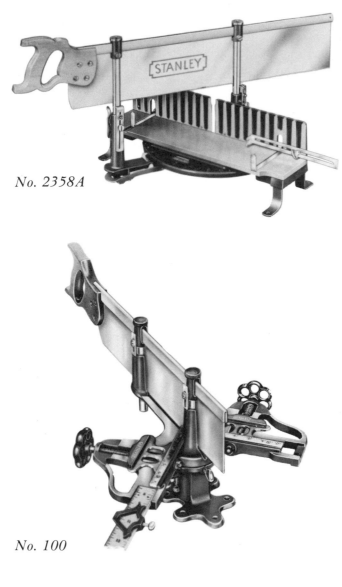

No. 2358A

No. 100

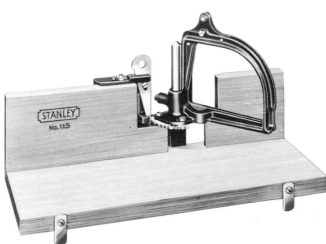

No. 115

biggest expenditure will probably be on your miter box. Absolute accuracy is mandatory—a 46° miter is not good enough; exact 45° cuts are necessary for exact 90° corners. Cheaper miter boxes can be used and in the beginning may be accurate, but with frequent use they tend to wear, wobble, and become completely useless. Aside from the loss of quality, the frustration of trying to join poorly matching miters makes the original saving seem rather pointless.

In our first demonstration we have used the most inexpensive miter box and backsaw we could find to show you that a frame can be built well with extremely simple equipment. However, for a more permanently serviceable and efficient tool we recommend one of the miter boxes pictured here or its equal. Throughout the rest of our book we have used the Stanley miter box No. 150, since replaced by model No. 2358A, shown here. This medium-price-range tool is of excellent quality, and unless one plans to go into framing as a business it is entirely adequate for any framing job.

In most professional frame shops you will find a tool called the Lion Trimmer. This tool can't be beat for cutting smooth, accurate miters in the shortest possible time. It is expensive but well worth considering if you intend to make framing a paying hobby. Even though it is seldom purchased by the occasional framer, the Lion Trimmer is such an excellent tool that we felt everyone in framing should at least be aware of it.

The Lion Trimmer is pictured here (page 15) with a measuring device attached, an attachment worth considering if you are planning to build a number of frames. How-to instructions come with it, of course, but our brief demonstration may help you decide whether or not to investigate further.

1. First we roughly cut our wood to shape with a hand saw, about $1/16$ inch (.2 cm) over size.

2. We place the wood into the trimmer about $1/32$ inch (.1 cm) beyond the edge of the blade. Then, holding the wood firmly against the bottom and back of the guide, we gently push the handle forward.

3. The razor-sharp blade trims thin shavings from the wood until we reach our predetermined length.

4. The final trim makes the wood unbelievably smooth and of course a perfect 45°. Next we would simply turn the wood around, place it against the adjustable stop on the opposite side of the trimmer, and repeat step 2.

Backsaw. Some miter boxes can be used with an ordinary carpenter's crosscut saw; however, these saws are too flexible to use for cutting frame miters. The accuracy needed for perfectly matching miters makes the backsaw essential. This saw has a stiff "spine" that insures a truly vertical cut and avoids any twist in the completed frame.

The backsaw you buy should be the best quality you can afford. A good one will retain its set and sharpness longer and cut smoother, truer miters more quickly than a cheap one. Economizing on this tool as on the miter box is often found to be a mistake in the long run.

Choose a saw about 18 or 20 inches (46 or 51 cm) long, 4 to 6 inches (10 to 15 cm) wide, with about 12 teeth to the inch (or 5 teeth to the centimeter). The length enables you to cut a miter with fewer strokes, and the fine teeth produce a smooth cut which makes matching and gluing easier. These qualities produce stronger, better-looking corners on your frames.

Clamps. All the expense and effort you put into cutting accurate miters will be to no avail if, during assembly, the corners of your frames are joined carelessly.

In order to produce professional corners, you must find some means of holding the molding exactly and firmly in place while joining. The best tool for this purpose is a miter vise designed expressly for the job. This specialized tool is rather expensive unless one is going to make enough frames to make it pay for itself, either in frame sales or in time saved. It does a perfect job, however, and its purchase should be considered by every serious framer. This type of clamp is found in most of the "you-frame-it" shops. You might like to look it over or even try it before you buy, if there is such a shop in your area.

In our search for new materials and methods we discovered a small corner clamp, tried it, and

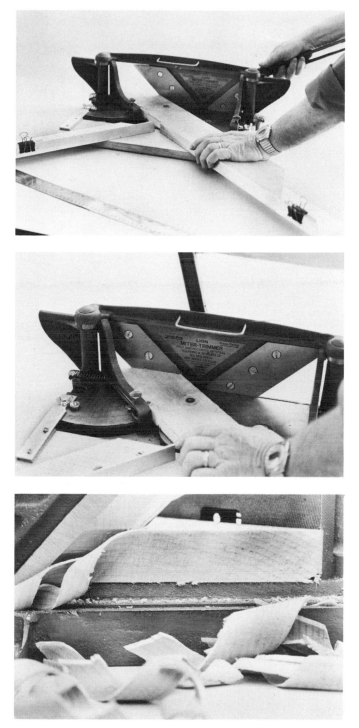

Using the Lion Trimmer

15

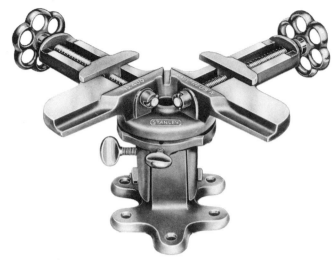

Miter vise

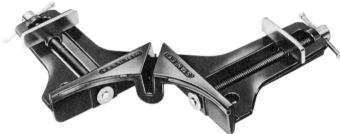

Corner clamp

found it completely adequate for moldings up to 3 inches (8 cm) wide. We have used it in all our demonstrations and recommend it as an economical substitute for the miter vise. Fastened to the top of your bench, it is a sturdy and practical joining tool.

In addition to using this as a miter vise, you will find these clamps excellent to use when it becomes necessary to hold a frame immobile for an extended period of time. For this reason, and because of their relatively low cost, we suggest buying four of them. They will always come in handy, even if you already own the more expensive miter vise.

You will also find a few small C clamps a worthwhile supplement to your joining tools.

Hammer. Your hammer should be chosen primarily by the way it feels. It should be well balanced and not so heavy that it tires the wrist. Try a number of them at your hardware store and buy the one that feels best. The one we use in our demonstrations is an inexpensive tack hammer.

Pliers. A pair of combination pliers will be very useful for removing nails and at times for driving brads into narrow moldings.

Nail set. Brads or nails are usually driven below the surface of the wood so that the holes can be filled. This prevents their discoloring the finish. A 1/16 inch (.16 cm) nail set will be all you will need at the beginning; later on you may find a variety of sizes desirable.

Ruler. Since we have been continually reiterating the need for accuracy in framing, it is obvious that the ruler you use must be of good quality to insure exactness in all your measurements. A good straight yardstick or, better, a six foot steel tape is imperative to good framing.

Glue. Here again one of our modern materials comes to our aid in reducing the fuss and bother of framing. A few years ago, only hot cabinet glue would have been recommended for joining frame corners. This practice, while sound, necessitated a gluepot, heat, melting glue, smell, and mess. Today we can make an extremely strong joint quickly and neatly by using one of the synthetic

resin glues available at any hardware counter. These glues come under a variety of trade names; all seem equally effective. They are easily recognized by their characteristic white color and pleasant odor. We recommend purchasing a one-pint squeeze bottle for ease of application and economy. Larger quantities are available and are even more economical if you will be building a large number of frames.

Fasteners. Probably everyone is generally familiar with brads and nails, but because picture framing is rather specialized a few words here will make it easier for you to select the right fastener for each job.

In the main we use brads to fasten the corners of our frames. Frame moldings vary considerably in their design, so it is a good idea to have a fairly wide selection of brads on hand. This need not be a large expenditure; brads are sold at reasonable cost in small quantities. They are graded by length and number; the number indicates their thickness. The lower the number the heavier the brad, the higher the number the thinner and finer the brad. Stick to Nos. 18 and 20 brads in lengths of ½ to 1½ inches (1 to 4 cm) for the present; as you gain experience and form preferences in moldings, you will find which sizes you use most often, and these can be purchased in larger quantities.

In addition to brads, on extrawide moldings corrugated fasteners are used to give added strength to the corners. These are patented fasteners that are driven into the back of the frame across the miters. They pull the inside corner together and prevent gaps from forming when the brads are not long enough to do the job by themselves.

We have been examining in some detail the tools that are essential for cutting and joining frames. These tools are a must for the basic construction. As you can see, a full cabinetmaker's tool chest is not necessary; however, there are other tools you may want to acquire. For instance, while they are not absolutely mandatory, a small hand drill and a set of bits are useful to have around a frame shop. A whetstone will keep your knife blades sharp for cutting mats. Also, as you become more interested in turning out frames of your own original design, a small plane, a wood

rasp or two, and a few small wood chisels will be a help in modifying standard moldings.

Rather than invest a large sum at the outset, we recommend that these and other supplementary tools be bought as they are needed to make specific jobs easier.

At the beginning of each demonstration you will find a photograph and a list of all the tools and materials needed for that particular operation.

What About Moldings?

Broadly speaking, there are two types of molding available to the framer: picture frame molding and builder's molding. The former is designed exclusively for use in picture framing while the latter is used for the trim in home building.

The biggest difference between the two is cost. Most frame molding is made from hardwood and is delivered to the frame shop prefinished. If you've ever purchased a few feet of picture frame molding you know how costly it can be. Picture frame molding also has a rabbet cut into it to hold the glass, picture, and backing. This feature makes building a frame a little simpler. However, it is difficult for the individual to buy picture frame molding unless he has access to a large supply center. Even then it is often necessary to buy a relatively large quantity of a single profile and finish in order to bring the price per foot within reason. Furthermore, unless one is very familiar with molding profiles, they can be difficult to visualize and disappointments can result.

While you can get help nowadays in the "frame-it-yourself" emporiums, we want to offer you ways to create original frames over and over again at relatively inexpensive prices. All these considerations made us take a long look at what builder's molding had to offer the framer.

First of all we found that builder's moldings come in an amazingly wide range of profiles and sizes. A great many of them make suitable picture frame moldings "as is," while a still greater number work excellently when combined with others. The over 80 frame variations we show in this book were designed using only 9 common profiles. The possibilities are unlimited; with a little thought the "right" frame can be designed

MOLDINGS

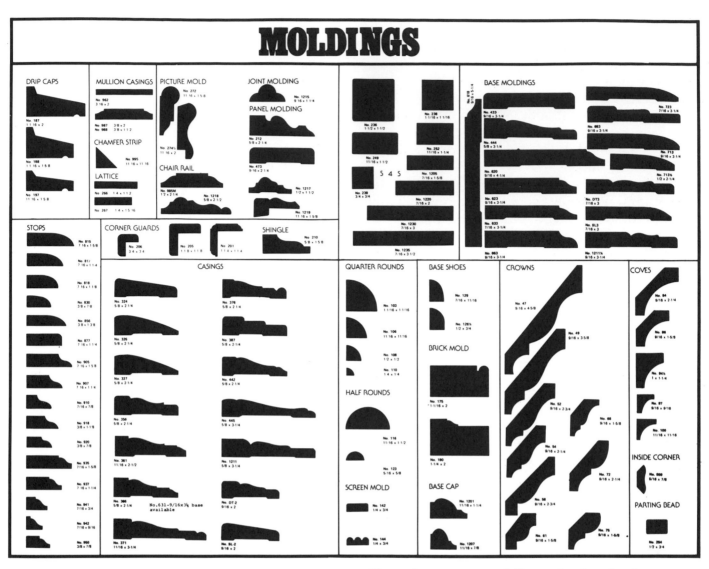

for any picture.

Some moldings are thick enough to have a rabbet cut directly into them; your lumber yard will do this for you at the time of your purchase; otherwise the rabbet can be made very simply by adding a strip of wood to the back of the molding. We use a standard ½ x ¾ inch (1 × 2 cm) parting strip or parting bead for this purpose. On these grounds, and because they are so inexpensive and easy for everyone to obtain, we have used builder's moldings for all our demonstrations. It should be kept in mind, however, that the principles of framing which we discuss will apply to any type of molding.

Moldings of course are the heart of picture framing; the effectiveness of any frame rests primarily on the design and proportion of its molding. Finding the right molding can be fun when you have some idea of what to look for.

Choosing your molding. Setting forth any set rules about which molding to choose for any given picture is always rather difficult. Tastes and trends in framing are continually changing and what today is "the way" to frame a watercolor, for instance, may be out of style in a relatively short time. Therefore, the following guidelines are given only as rather general characteristics of how various types of pictures are framed today. It is hoped the reader will feel free and stimulated to bring his own innovations to any framing project. In this way picture framing will be kept a lively and exciting art.

Oil paintings are always framed without glass. The moldings found most suitable are generally fairly wide and deep, although this is not necessarily always true. Conventional or academic subjects usually look good in frames 4 to 6 inches (10 to 15 cm) wide, while a simple, thin strip frame is all

that is required for some of the more abstract pictures.

To make the transition from picture to frame smooth and harmonious, an insert or liner will often be found desirable. In fact, the use of an insert should always be considered when framing a conventional oil painting.

Original black-and-white prints and drawings are usually framed under glass with a white or off-white mat. The molding is generally rather narrow and either natural wood, black, or white.

Original color prints are framed in the same way, although having the added virtue of color, they permit more originality in the use of color in the mat and frame.

Don't overlook gold or silver gilding. Sometimes a bright metallic look will complement a strong black-and-white or color photo or print, and create an exciting contemporary look for your wall.

Watercolors are always framed under glass and are usually matted in either white, gray, or a color that enhances the painting. Watercolor frames have become more and more experimental and creative of late. Perhaps this is an effort on the part of the artist to destroy the "little medium" tag that has been applied to watercolor for so many years and to give the work equal status with oil painting. At any rate the trend is a welcome one.

Prints and reproductions are best framed in a style suitable to the original medium.

Since the designs of builder's moldings are based on function, they are fairly standard. You may find, however, that the style or pattern of the decoration used will vary slightly in different sections of the country. At your lumber yard you will find a chart similar to the one shown here. From it you can get an idea of the stock your dealer has available. Then go right to the molding racks and browse. Not only will you have fun poking around, but you will find that seeing the actual moldings will help to generate ideas for frame designs. Very often a cross section on a chart will not be as visually effective as the molding itself.

Sometimes the exact profile you have in mind will not be obtainable and a compromise becomes necessary. By actually having the moldings at hand, the closest likeness can be found.

The molding we use for our insert is a good

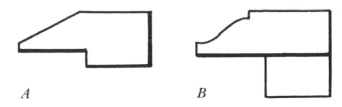

A B

example of such a compromise. The profile we were looking for was something like illustration A (above). The nearest thing we could find was a 1¾ inch (4 cm) molded stop of a style popular in this locale. It has a silhouette like illustration B. We could see immediately that, with the addition of a parting-strip rabbet, it would do the job excellently.

One of the most versatile builder's moldings we've used is called "drip cap." It comes in several sizes and combines beautifully with other moldings. Be sure to try all the lumber yards. In some areas of the country your dealer may have to order it for you. While you're waiting, try to find a molding whose cross section comes close to the drip cap illustrated below.

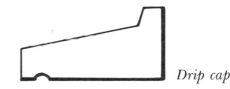

Drip cap

When you decide on a molding, pick over the supply for the best strips. Check for warpage by sighting down each strip. Choose strips that are free of knots and have no excess sap or bark areas. It is important also to check that the molding profile has not been broken down or worn in handling. The little extra effort it takes to go through a pile of molding will be repaid with less waste and better-looking finished frames.

Moldings are sold in even foot lengths: 6, 8, 10, 12, and 14 feet (180, 240, 300, 360, and 420 cm). You can easily find how much molding to purchase for each frame by adding the lengths of the four sides of your picture and eight times the width of the molding. This allowance is one which beginners are apt to forget; remember, the miters will add length to each side of the frame.

As an example let's assume we are going to buy enough 2 inch molding to frame a 16 × 20 inch picture. By adding: 16 + 16 + 20 + 20 + 16 (the width allowance), we can see that we will need 7 feet 4 inches of molding. (Or, for 5 cm molding to

frame a 41 × 51 cm picture, we would add 41 + 41 + 51 + 51 + 40 to total 224 cm needed.) A little excess is better than not enough, so we would buy an 8 foot (240 cm) strip of the molding. The short scraps left over from strips like this make excellent test pieces for trying finishes, or for building sample corners.

After a few excursions among the stacks of lumber at your dealer's, you will become quite adept at finding the correct profile molding for all your pictures.

Points to remember when shopping for moldings

1. The design of the molding you choose must relate to the picture you are framing.

2. A traditional painting looks best in a frame with a familiar, timeworn (traditional) feeling.

3. A positive, bold painting demands a frame with strong, simple lines.

4. Light, airy compositions should be surrounded with a frame of comparable delicacy.

5. A picture whose paint quality has a distinctly textural feeling is complemented by a frame rich in texture.

6. Modern two-dimensional pictures are best framed with moldings that are either flat in profile or recede toward the wall.

7. Compositions employing traditional perspective are further enhanced by a molding design that is fairly deep and slants in toward the picture.

What About Finishing?

The second half of our book is devoted to the various ways you can finish picture frames. The subject of finishing is an important one, because in the final analysis the success or failure of a picture's presentation will depend upon the finish of its frame.

The finishing demonstrations start on page 85. In this section we demonstrate toning, texturing, gilding, cutting glass and acrylic, mat cutting, covering mats and inserts, mounting prints, refinishing antique frames, archival preparation, and wiring pictures for hanging.

Each demonstration treats in detail the tools and materials used for that particular operation. However, before you start, a few brief comments on the aims of finishing and on some of the specialized materials used are in order.

In this phase of picture framing, as with construction, we experimented with new materials and methods. For each operation, we present the simplest and least involved way for you to achieve professional-looking finishes.

A good finish must not clash with the picture; therefore, as a general rule, any finish you use should be rather neutral in character. Depending on the qualities of the picture, a warm or cool gray tone will be found most suitable. While the grayness can be modified slightly to fit special traits, remember that in a frame finish a slight leaning toward neutrality is much preferred to too dark or intense a color.

The most exciting and useful new finishing materials we found are the extra thick "no-drip" or texturing paints, now available for home decorating. These can be purchased in any paint store under a variety of trade names and are made expressly for creating textures while you paint. They usually have a plastic or vinyl base and are water soluble. For simplicity we will refer to the paint we use throughout the rest of the book as "vinyl base paint."

The paints are usually mixed to a heavy consistency and come in many colors. For frame-finishing purposes you need buy only white. Its extra thickness allows it to be used undiluted as a means of texturing your frames. Tinted with inexpensive colorants and thinned with water, it will also make excellent toning washes called *patinas.*

Patinas. To avoid harshness and ensure a pleasingly soft tone in your patinas, it is always advisable to start with a basic gray and modify it to suit the particular picture you are framing. You could start each patina right from the white, but this takes longer than is necessary and is apt to result in colors that are too strong and overpowering.

On page 86 we show you how to mix a basic palette of finishing patinas. We use the thick white paint, raw umber, and black to arrive at a neutral gray patina which provides the base for any further mixing.

Glazing. This process, as its name implies, consists of wiping a thin, transparent wash of color over a frame. While a glaze takes comparatively longer to dry than a patina, it is sometimes useful in making fine adjustments of tone over a patinized frame or as a means of darkening natural wood moldings.

Almost any color can be used when glazing. As in any finishing operation, however, neutrality and harmony should be sought.

The quickest and simplest way to glaze a frame is to dip a large pad of cloth into a thin mixture of oil color and turpentine and wipe it quickly across the surface to be toned. If the tone is too dark it can easily be lightened by rubbing very lightly with fine steel wool.

Gilding. This traditional art has long been the trickiest of finishing operations. Whole books have been justifiably devoted to this subject alone. Skill in handling the fickle leaf takes years to acquire, and the amateur has always been warned against trying the rather ticklish procedure. Even if he did finally make a good gild, was the amount of time it took worth it?

We believe gilding is fun, so we set about finding ways that would encourage even beginning finishers to try it.

It is always advisable to apply metal leaf to a smooth surface. Preparing the ground can become an art in itself. The ground is usually made of gilder's clay, which can be finished to a glasslike smoothness.

Our heavy-bodied white paint again proved to be the solution to a knotty problem. We found that by coating the area to be gilded with this paint, undiluted, and steel wooling each coat, any degree of smoothness could be arrived at quickly and simply.

Of course, achieving expertness in handling the leaf will still take time, but the three gilding methods we show you will, we hope, stimulate you to explore further this facet of finishing.

Mounting prints. A print, map, photograph, or drawing is fastened to a heavier backing in order to give it more substance and permanence. The procedure is a simple one which you should have no difficulty in following.

The prime factor in mounting any picture is the adhesive used. It should have good holding power, be clean and easy to use, and not create excess warpage when it dries. It's also important that the adhesive contribute as little as possible to any normal deterioration of the piece being mounted.

There are many adhesives on the market, but the one we use in our demonstration has all these qualities and is also water soluble, which makes brush cleaning easy. It dries smoothly and quickly under light pressure.

Now to Work

Utilizing the benefits of contemporary ideas and materials does not imply a desire to produce novelty at any cost. Ideally a picture frame should combine the best of the traditions of the past, the tastes of the present, and the visions of the future. The wide range and flexibility of today's materials provide the means with which the framer can free his or her mind from thoughts of chemistry and fuss and instead concentrate on the really creative aspects of the art.

We must always remember that a picture frame, no matter how creative or original, does not exist for itself. It should be conceived as an integral part of the living space in which it is seen. The framer's job is to create a visual bridge or stepping stone between the picture and its environment, which invites the viewer to visit the world contained within.

Simplicity is the key word in our presentation, and the modern framer, when faced with the choice of which molding or finish to use on a particular picture, will not go wrong if he will keep this word foremost.

A frame is after all four simple sticks . . .

CONSTRUCTING

The Basic Frame

When you have completed this frame (see page 37), you will have mastered the fundamental techniques you will use in making all the other frames: constructing the basic insert, the 1 × 4, and a molding—in this case, the drip cap—and joining those elements. The insert will be used with most of the subsequent frames we demonstrate, and the 1 × 4 and the drip cap will also be used again. So follow these instructions carefully, and it'll be smooth sailing afterward!

The Basic Insert

The basic insert we demonstrate here consists of two wooden rectangles, one of which is fastened to the back of the other. The rectangle in front is the face of the insert; the rectangle in back forms the rabbet to hold the picture.

For the face of the insert we use a 1³/₈ inch (3.5 cm) molded stop. The rabbet is made from a ¹/₂ × ³/₄ inch (1.3 × 1.9 cm) parting strip.

We start by building the rectangle that goes next to our picture and forms the rabbet.

First, some advice about cutting miters: Always hold the molding in a firm grasp against the bottom and back of the miter box. The wood must not move as you make your cut. Keep the saw in a horizontal position and apply only very light pressure. Let the sharp saw teeth do the work and you will have a straight, smooth cut ready for gluing. Badly cut miters that have to be filled with wood filler look sloppy and eventually come unglued. This is not to say you can't use a little filler once in a while but remember, properly cut miters won't need it.

Tools. Miter box, backsaw, corner clamp, hammer, yardstick, pencil.

Materials. One 8 foot (244 cm) piece molded stop, one 8 foot (244 cm) piece parting strip, ³/₄ and 1¹/₂ inch (1.9 and 3.8 cm) brads, glue.

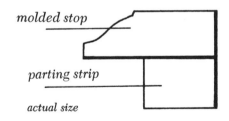

molded stop

parting strip

actual size

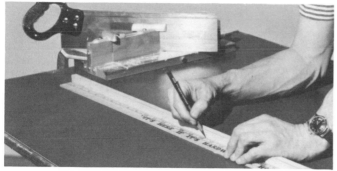

1 Measuring. We cut about ¼ inch (.6 cm) from one end of the parting strip to square it. We then mark it 16⅛ inches (41 cm) from the squared end. The ⅛ inch (.3 cm) is added to any picture measurement to allow some play for easier fitting.

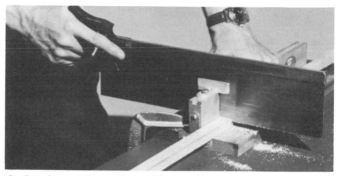

2 Cutting. When the rabbet strip does not show in the finished frame there is no need to miter the corners; we can make it stronger by using simple butt joints. Holding the strip firmly in the miter box we make the first 90° cut at the 16⅛ inch (41 cm) mark.

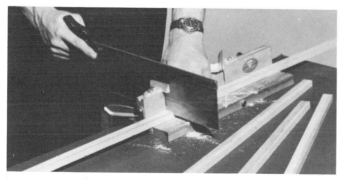

3 Measuring. Using the first piece as a pattern we mark the second short side. By doing this we ensure that both pieces will be exactly the same length.

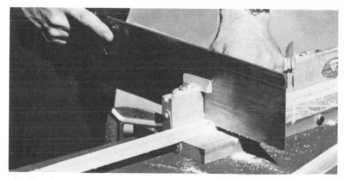

4 Cutting. Now we are making the second 90° cut.

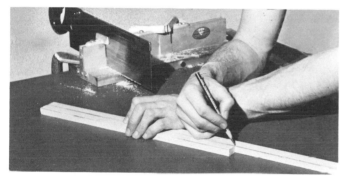

5 Cutting. Here we are making the final cut. The two shorter sides have been made and we repeated the first three steps to make the longer ones. In measuring the long sides allow ⅛ inch (.3 cm) for play and an additional 1½ inches (3.8 cm) for the overlap needed to make the butt joint. These strips will be 21⅝ inches (54.9 cm) long.

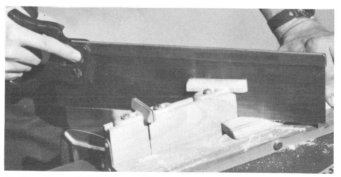

6 Cutting. With the rabbet strip cut, we make the first 45° miter near the end of the molded stop. Be sure the angle is in the right direction; the slanted edge of the wood will go inside next to the picture.

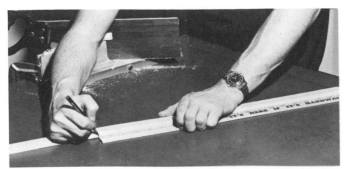

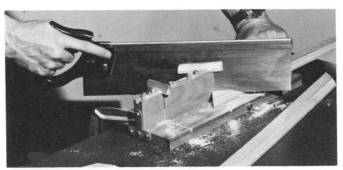

7 Measuring. Mitered pieces will normally be measured on the inside or short edge of the molding. However, when we assemble the insert, the square edge of the molded stop has to match the outside edge of the rabbet strip; therefore we are measuring $21^5/_8$ inches (54.9 cm) along the outside edge.

8 Cutting. Having cut the first long side, we now cut the first miter on the second side.

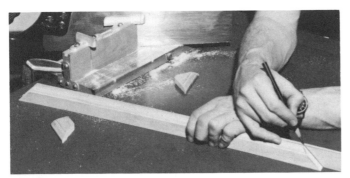

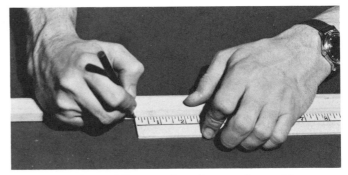

9 Measuring. With the end of the remaining stock mitered, we are using the first side as a pattern to mark the second long side.

10 Measuring. After cutting the two long sides we again mark the outside edge of the molding, this time for the first short side. Make this piece $17^5/_8$ inches (44.8 cm).

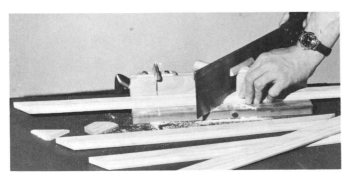

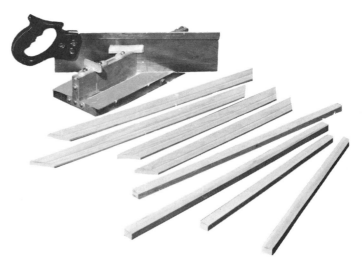

11 Cutting. Now we use the first short side as a pattern, then cut our final miter. With this operation the cutting of the insert is complete—four pieces of molding for the face of the insert and four pieces of parting strip for the rabbet—and ready to assemble. (See picture at right.)

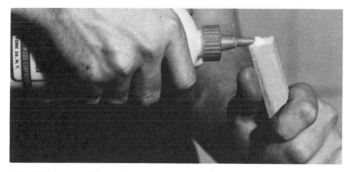

12 Gluing. Choosing one long and one short side of the parting strip, we apply glue to one end of the shorter piece. Cover the surface fully.

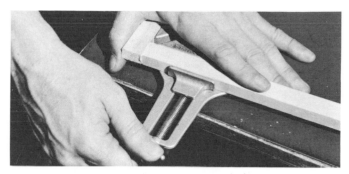

13 Clamping. Here the two pieces have been placed together and locked in the corner clamp ready for nailing. The long side covers the end of the short one as shown. Make sure the strips are flat against the bottom and sides of the clamp. Tighten each side gradually; the clamp will then bring the surfaces evenly and firmly together.

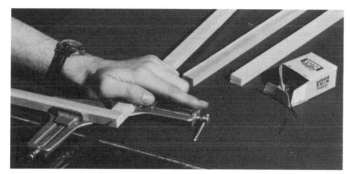

14 Nailing. We use two 1½ inch (3.8 cm) 20-gauge brads in each corner. With the clamp as tight as possible the first brad is driven in near the outside edge.

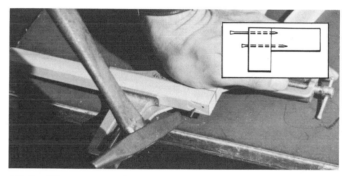

15 Nailing. For added insurance against twisting, the second brad is placed near the inside edge of the strip, slightly lower than the first.

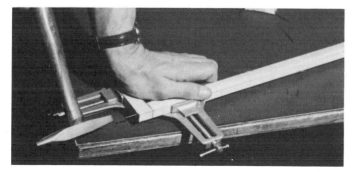

16 Nailing. One half of the rabbet is now done. We go through the same operations with the second half, making sure the long piece overlaps the short one.

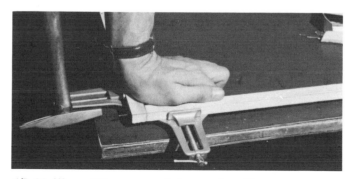

17 Nailing. The same gluing and nailing steps are used to join the two halves into the finished rabbet strip.

18 Gluing. With the rabbet strip completed we begin to assemble the face of the insert. We apply glue evenly to the mitered surfaces of the molded stop.

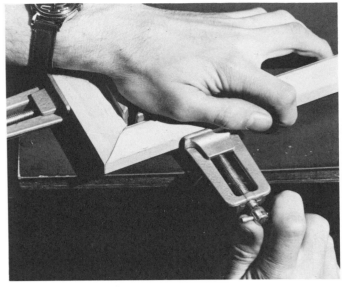

19 Clamping. The glued ends of one long and one short side of molded stop are placed in the clamp. Tighten each side of the framing clamp gradually, pulling the miters together at the inside corner. The edges should match.

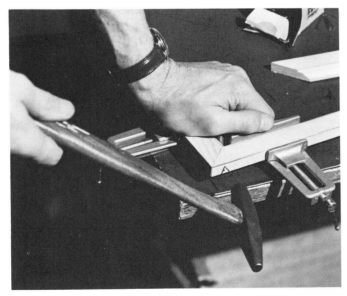

20 Nailing. Drive two brads in this corner; place one of them as close as possible to the inside edge of the molding to help prevent twisting the frame.

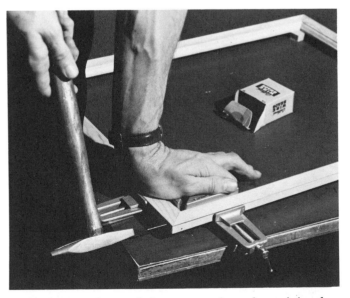

21 Nailing. Three of the corners have been joined and the final brad is being driven home. A small block of scrap wood under the previously assembled corners keeps the halves level and assures a "flat" frame.

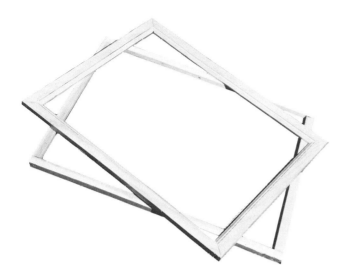

22 Ready to assemble. The face and the rabbet strip are both completed and ready to be joined.

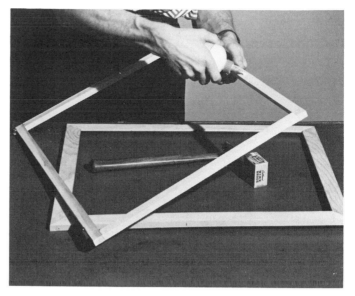

23 Gluing. Covering one entire surface of the rabbet strip with glue prepares it for joining.

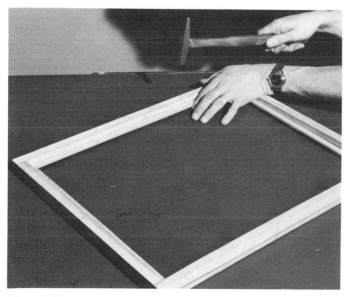

24 Nailing. The glued surface of the rabbet strip is placed on the back of the molding with the outside edges carefully matched. Some ³/₄ inch (1.9 cm) brads, our hammer—and the insert is complete.

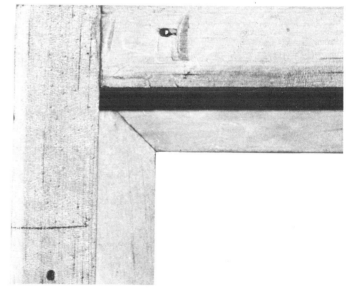

The completed insert
back view

1 × 4 Flat

The frame we illustrate here is never used by itself. However, in combination with other moldings and inserts it provides the basis for an astonishing variety of excellent frames. It is simple to build and you should have no trouble following the step-by-step demonstration—and, incidentally, picking up some excellent experience which will help later on when you tackle more complicated moldings.

Note: there was a time when a 1 × 4 measured 1 × 4 inches (2.5 × 10.2 cm). No longer; what we all still refer to as a 1 × 4 in fact measures $^3/_4$ × $3^9/_{16}$ inches (1.9 × 9.1 cm).

Tools. Miter box, backsaw, C clamps, hammer, yardstick, pencil, square, nail set.

Materials. One 10 foot (305 cm) piece 1 × 4 (1.9 × 9.1 cm) clear pine, basic insert, 6-penny finishing nails, corrugated fasteners, glue.

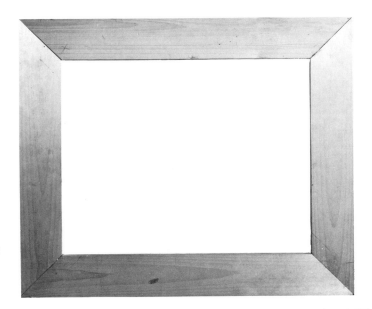

actual size *1 × 4*

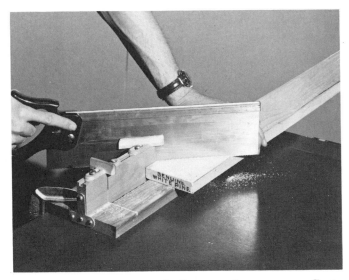

1 Cutting. From one end of our stock we cut our first 45° miter. Make sure the wood is held firmly and *flat* against the bottom and back of the miter box.

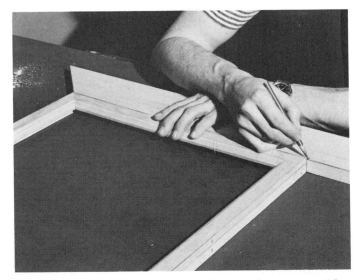

2 Measuring. We use the completed insert as a guide to measure the first short side. Allow about $^1/_{16}$ inch (.2 cm) extra here for easier fitting.

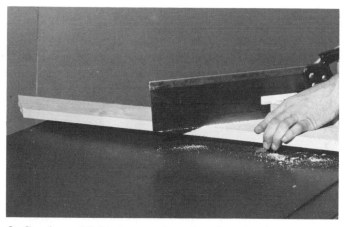

3 Cutting. Making sure the miter is going in the right direction, we cut the first piece of our frame.

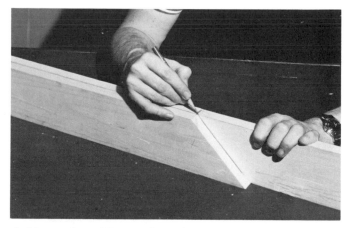

4 Measuring. No need to trim off the end again; with a flat board like this we just match the first piece to the mitered end, mark it carefully, and we're ready to cut the other short side.

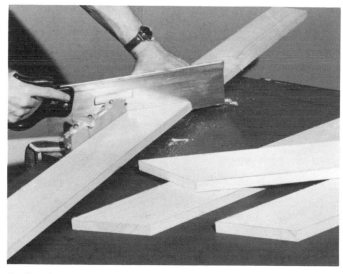

5 Cutting. Now the two short sides are finished. We have measured one long side against the insert—against allowing 1/16 inch (.2 cm) for play—cut it, and used it to mark the final piece which we are cutting here.

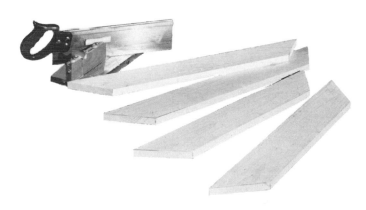

6 Cutting completed. The frame is now cut and the four sides are ready to be joined.

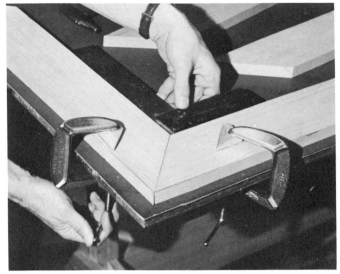

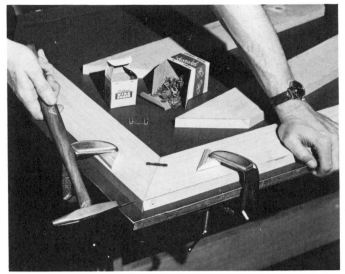

7 Gluing and Clamping. We have coated the mitered end of one of the short sides fully and evenly. Our corner clamp will not take a molding this wide, so we are using C clamps to hold the wood against the flat surface of the table. Small pieces of scrap wood are used under the clamps to prevent scarring the surface. The corner must make an exact 90° angle, so we check the inside edge with our square. With the clamps almost tight you can adjust the angle of the corner exactly with light taps of your hammer. Make sure the miters are firmly together, tighten the clamps, and your corner is ready for nailing.

8 Nailing. In this step we have driven a corrugated fastener across the miter, and are pulling the outside edges together with 6-penny finishing nails. When these nails have been driven in we will further strengthen the corner with another fastener.

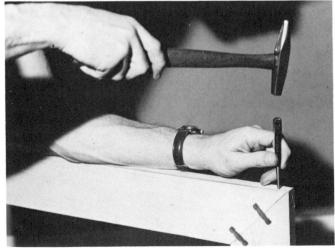

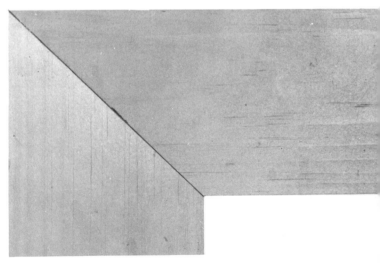

9 Setting. Since the corners of this frame will be visible, we are setting the nails. Place the nail set on each nailhead and tap lightly until the nailhead is well below the surface of the wood. The holes will be filled with wood dough. You will find this operation easier to perform if you hold the finished frame vertical on the floor.

The completed 1 × 4 flat

Drip Cap No. 1

For the frame maker drip cap is one of the most versatile moldings to be found in the lumber yard. Here is the first of many handsome picture frames you can build with this simple molding.

There are areas of the country where the home construction methods don't require a lot of drip cap. Be sure to try all the lumber yards in your vicinity. If no one has it, try asking the most pleasant dealer to order enough for your needs. If that doesn't work, look at the wall chart of his moldings and pick out the one that comes closest to matching the simple profile of the drip cap—one like the casing shown here.

Tools. Miter box, backsaw, yardstick, pencil, corner clamp, hammer, nail set.

Materials. One 8 foot (244 cm) piece drip cap molding, glue, 1$\frac{1}{2}$ inch (3.8 cm) brads.

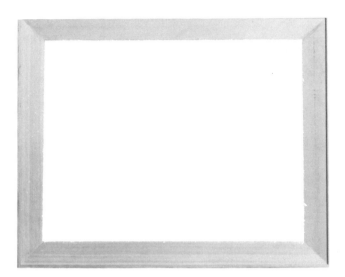

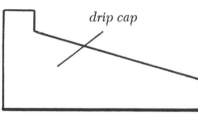

drip cap

actual size

casing DT−2

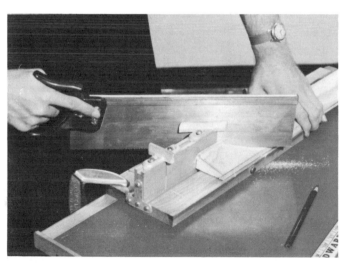

1 Cutting. We start by holding the drip cap firmly against the bottom and back of the miter box and make the first 45° cut, near the end of the strip. Be sure the miter cut is made in the right direction: for this frame the shorter, thinner edge of the drip cap will go next to the insert.

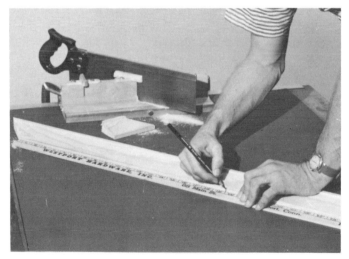

2 Measuring. Now we measure the first long side of our frame: 20$\frac{5}{8}$ inches (52.4 cm) *along the inside edge*. This will allow about $\frac{5}{8}$ inch (1.6 cm) of the insert to show next to the picture.

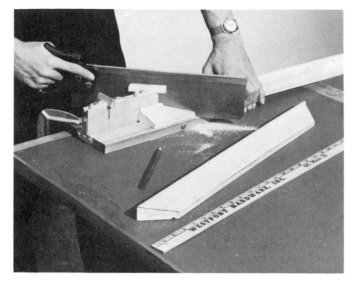

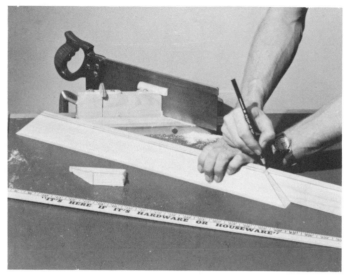

3 Cutting. Having made the cut that completes the first long side, we now start our first cut on the second long side.

4 Measuring. Using the first side as a pattern, we mark the length on the uncut end of the second piece, and make the cut that completes the two long sides.

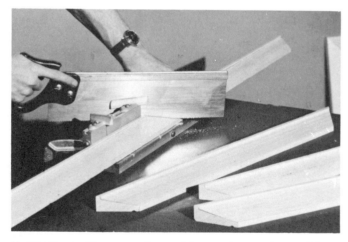

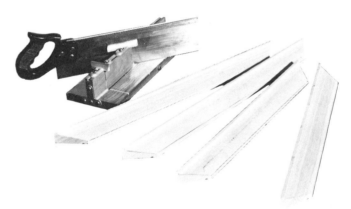

5 Cutting. Here two long sides and one short side have been completed. We are cutting the second short side, which measures 16⅝ inches (42.2 cm) on the inside edge, again leaving ⅝ inch (1.6 cm) of insert exposed.

6 Cutting completed. The four pieces of drip cap molding have been cut and are ready for assembly.

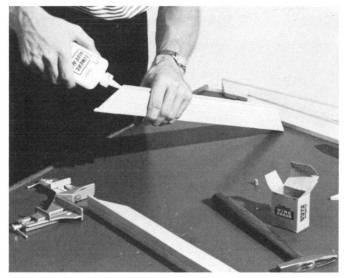

7 Gluing. Choosing one short and one long piece of drip cap, we apply glue evenly to the cut surfaces.

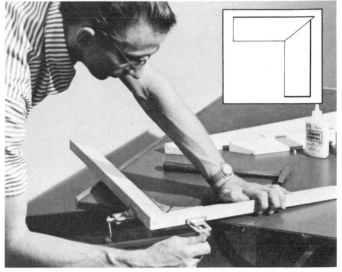

8 Clamping. Here the two glued surfaces have been fitted together and are being locked in the corner clamp for nailing. Keep any discrepancy in the sizes of the two pieces on the outside. This "overhang" can be sanded off later. (See drawing.)

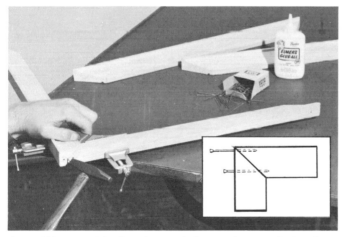

9 Nailing. With the clamp tightened we nail the first half together with two brads. To prevent twisting we space them as shown in the drawing.

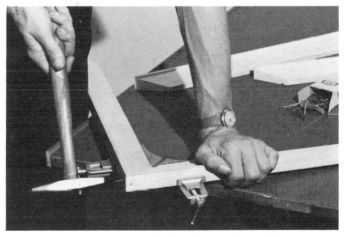

10 Nailing. Here we nail the other side of the corner. If glue oozes out while you nail, just wipe it off.

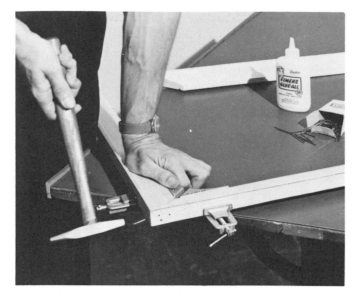

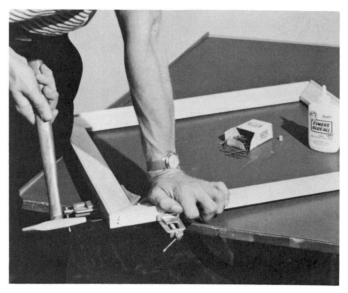

11 Nailing. One half of the frame is done, so we go through the same joining operation with the second half.

12 Joining. With each half of the frame assembled, we now glue and nail the two halves together.

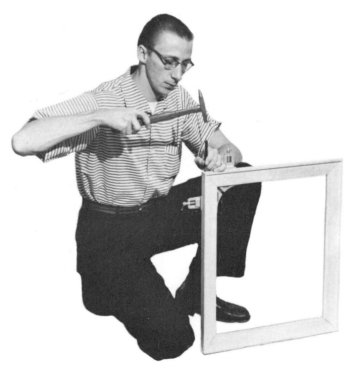

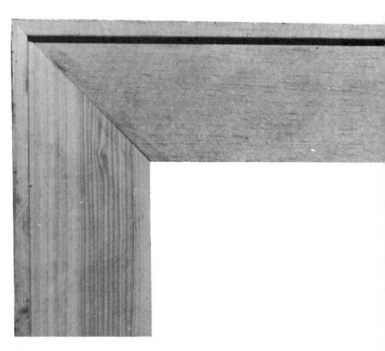

13 Setting. Holding the frame in a vertical position we set the nails. We use the corner clamp in each corner as an extra precaution against springing the joints.

The completed drip cap no. 1

Combining Insert, 1 × 4, and Drip Cap

Here is where careful workmanship pays off. If our three rectangles—insert, 1 × 4, and drip cap—are accurate, we will shortly have our first frame completed, ready for finishing.

Tools. Hammer, pliers.

Materials. Glue, 1¼ inch (3.2 cm) nails and brads, basic insert, 1 × 4 flat, drip cap no. 1.

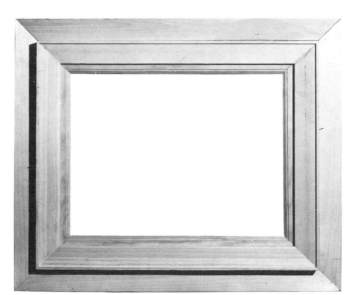

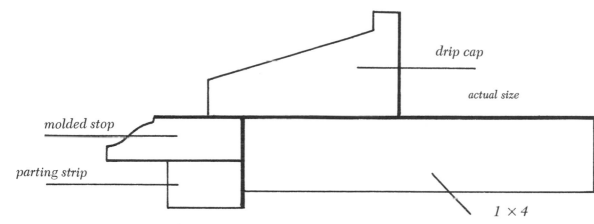

drip cap

actual size

molded stop

parting strip

1 × 4

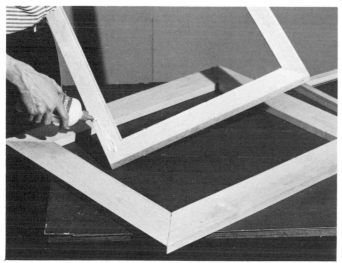

1 Gluing. Squeezing glue over the entire back surface of the drip cap rectangle prepares it for joining.

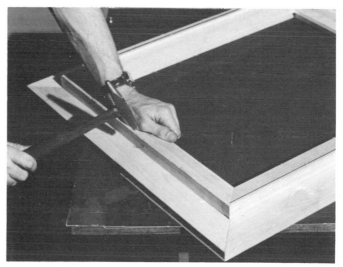

2 Temporary nailing. With the 1 × 4 rectangle face up (corrugated fasteners down), we center the drip cap equidistant from the outer edges, making sure the miter cuts match at the corners. We toenail (drive a brad at an angle) through each side of the drip cap *partway* into the 1 × 4 beneath.

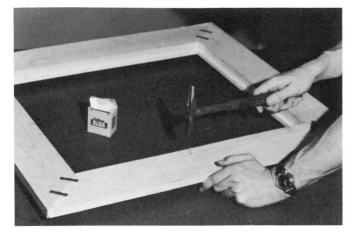

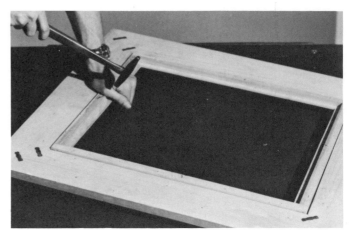

3 Permanent nailing. Turning the frame over we drive brads through the 1 × 4 into the drip cap underneath. Three brads in each side will hold.

4 Installing the insert. We drop the insert face down into the opening in the back of the 1 × 4 rectangle, against the drip cap. We toenail the nails *partway* into each side through the back of the insert into the 1 × 4. No glue and only four nails are used here, as the insert should be removable.

Flip the frame over, with the pliers withdraw the temporary nails from the front of the frame, and there it is!

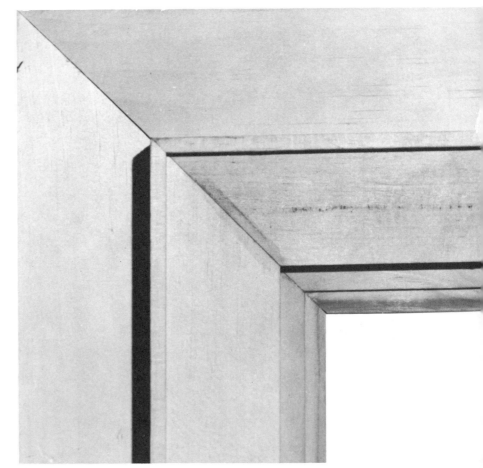

The completed frame

Drip Cap No. 2

Here is a striking reverse frame, completely different in character from the first frame we showed you, although it is made from the same drip cap molding and a basic insert.

Tools. Miter box, backsaw, yardstick, pencil, corner clamp, hammer, nail set.

Materials. One 8 foot (244 cm) piece drip cap molding, basic insert, glue, 1½ inch (3.8 cm) brads.

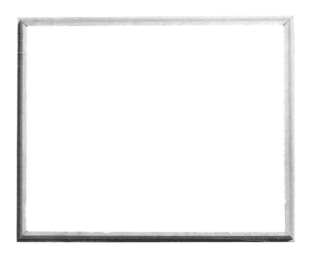

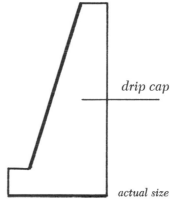

drip cap

actual size

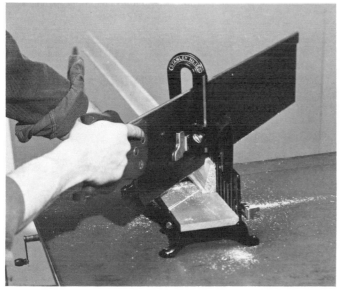

1 Cutting. With the drip cap molding held firmly in the miter box we trim off the end of the stock, making our first 45° miter. Notice the position of the molding: for this frame design the drip cap is held in a vertical position.

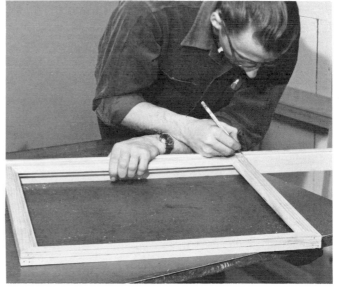

2 Measuring. We now hold the mitered end against the edge of the insert and mark the first long side of our frame. Make this measurement very carefully; when assembled the molding must fit exactly around the insert.

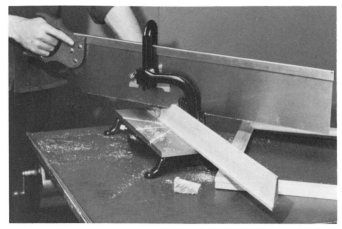

3 Cutting. Holding the drip cap in the same position as in the first step we swing the saw of our miter box to the opposite 45° angle and make the second cut, completing the first long side of our frame.

4 Measuring. We swung the saw and cut the first miter·on the second side, duplicating the first step. Then matching the two mitered ends we use the first side as a pattern to measure for the second miter.

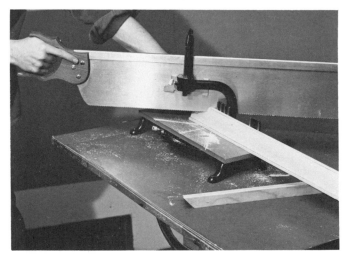

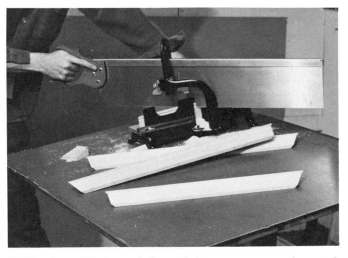

5 Cutting. Now we place the molding in the miter box in the same position, swing the saw and cut the second long side.

6 Cutting. We have followed the same measuring and cutting operations and are now making the final miter on the second short piece.

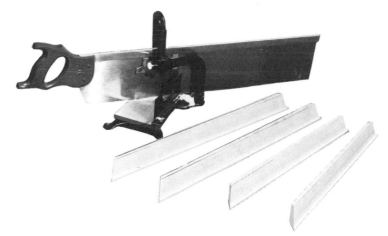

7 Cutting completed. Ready for joining: compare these four pieces with those of the frame on page 34. Turning the drip cap completely changes the design.

8 Gluing. Next we apply a liberal coating of glue to the miters of one long and one short side.

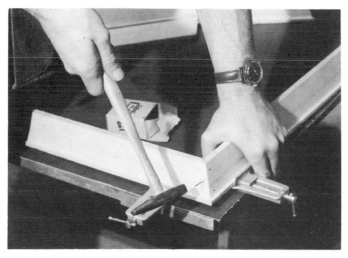

9 Nailing. We carefully clamp the corners and drive two brads into one side and one into the other. To avoid scarring the frame we don't drive the brads all the way in.

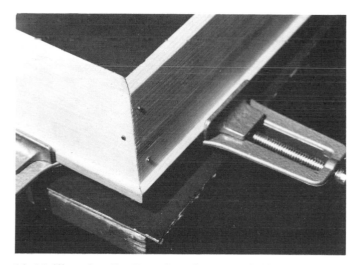

10 Nailing detail. Here is a close-up of all three brads in place. Notice that the heads are still above the surface of the wood.

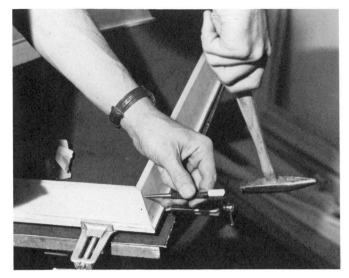

11 Setting. By setting the brads we will have only three small holes to fill.

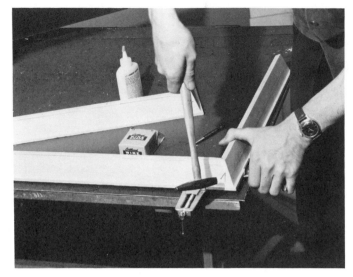

12 Nailing. Here the second half of our frame is in the clamp and the final brad is being driven in. Set these brads and the two halves are ready to be joined.

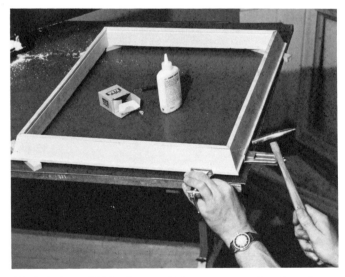

13 Joining. With three of the corners glued and nailed, we are now nailing the final one. We use small scraps of parting strip under each corner to keep the frame level and untwisted.

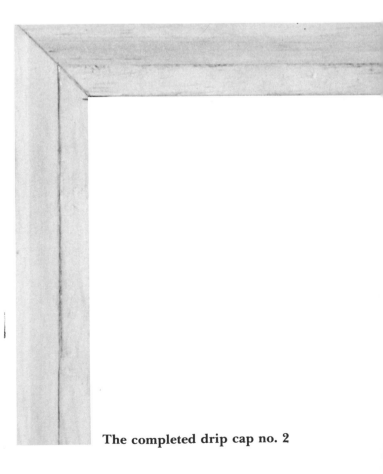

The completed drip cap no. 2

Combining Insert and Drip Cap No. 2

The reverse drip cap combines with the basic insert to create a frame that gives a picture substance. It works especially well with pictures that rely on their two-dimensional design for impact.

Tools. Hammer.

Materials. Basic insert, drip cap no. 2, glue, 1 inch (2.5 cm) brads.

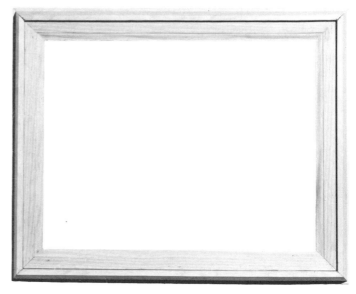

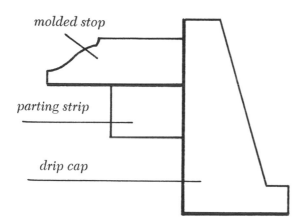

molded stop

parting strip

drip cap

actual size

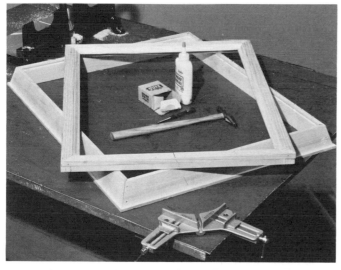

1 Ready to assemble. Our frame is completed, and, if we have measured carefully, ready to be joined with the insert.

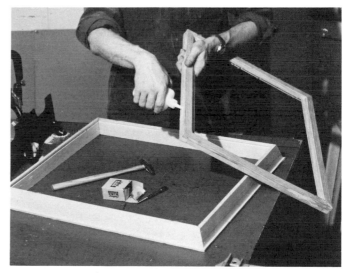

2 Gluing. We have tried our insert and it fits perfectly, so we apply glue all around the flat outside edge.

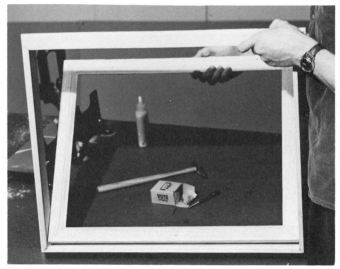

3 Positioning insert. Holding the frame vertical makes it simple to slide the insert in from the back. Any excess glue that squeezes out will then be on the back where it can't spoil the looks of our frame.

4 Positioning detail. To make sure our insert is in the right position we line up its top edge with the bottom edge of the groove on the inside of the drip cap.

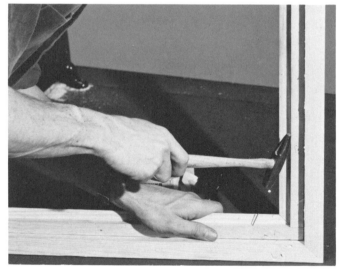

5 Nailing. With the frame still vertical and the insert in position, we nail through the rabbet strip, fastening the insert to the drip cap.

This shot is a good demonstration of why we slide the insert in from the back of the frame. The slight irregularities apparent on the inside edge of the drip cap are the small beads of excess glue squeezed out by the tight fit. They would be most unwelcome on the front edge.

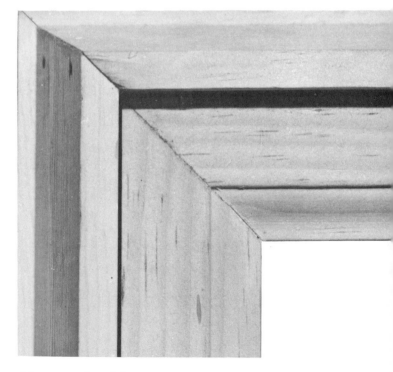

The completed frame

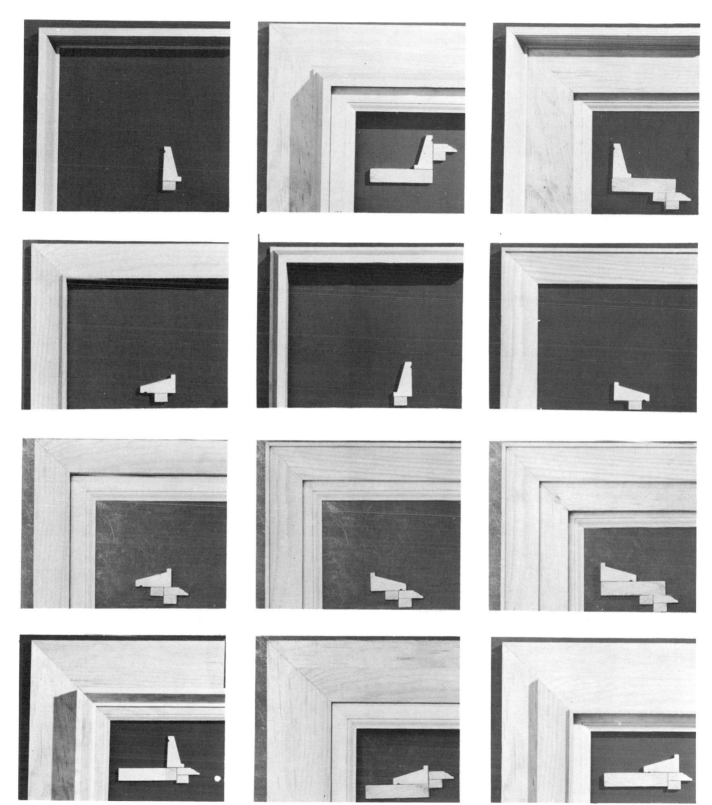

Try these variations—find others. *At the end of each section we'll show you a few alternative ways we've found to combine the moldings on which we've been working. Use these suggestions as a start to get your imagination moving. Any combination is okay—as long as it helps to present your picture at its best.*

As a help in trying different combinations, cut ¼ inch (.6 cm) slices off your stock of moldings, as we did here, and then move them around to explore the many variations.

Clamshell No. 1

On the next few pages we will show you how a molding normally used for interior trim can be made into a handsome modern frame. You'll find that clamshell molding, plus the basic insert, makes a design that will complement most pictures.

Tools. Miter box, backsaw, yardstick, pencil, hammer, C clamps, square.

Materials. The basic insert, one 10 foot (305 cm) piece clamshell (wide), corrugated fasteners, 1½ inch (3.8 cm) brads, glue.

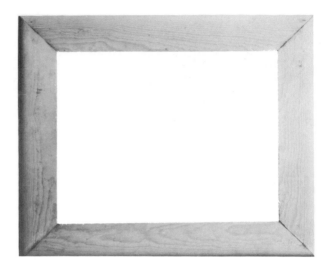

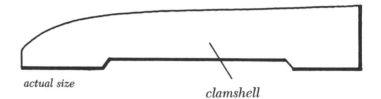

actual size *clamshell*

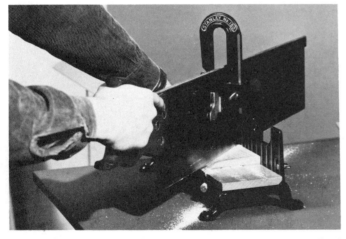

1 Cutting. We start by cutting a miter on one end of the molding. For this frame design, the square end of the clamshell is held against the back of the miter box.

2 Measuring. We mark the long picture dimension, plus ⅛ inch (.3 cm) for play, along the square inside edge of the molding.

3 Cutting. With the saw swung to the opposite 45° angle and the clamshell held firmly, we cut the first long side.

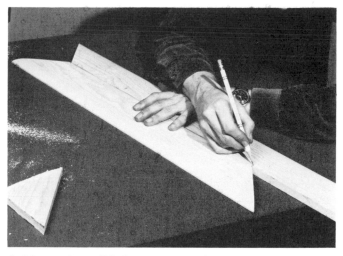

4 Measuring. We have repeated the first step and are using the first piece as a pattern to measure the second long side.

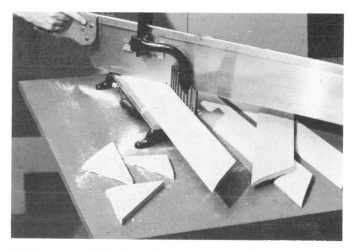

5 Cutting. Following the same measuring procedure for the short sides, we are here cutting the last miter. Now the four pieces of clamshell molding are ready to be joined.

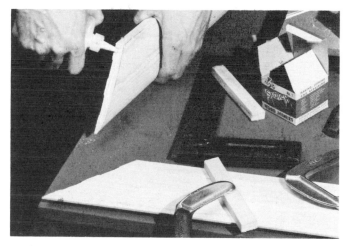

6 Gluing. With one long side clamped face-down to the table with a C clamp, we spread glue on the end of one short side. A piece of scrap wood under the clamp prevents marring the surface.

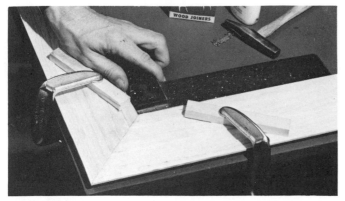

7 Clamping. We check the corner for squareness, tighten the clamps firmly, and the corner is ready for fastening.

8 Fastening. We drive one corrugated fastener across the miter.

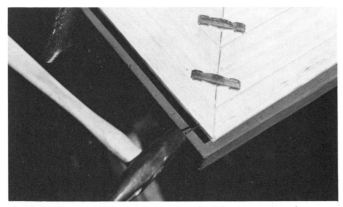

9 Nailing. After putting a second fastener in place we drive a brad into one side to keep the thin edges of the molding together. Then we repeat the fastening and nailing steps, completing the second half of our frame, and our joining is finished.

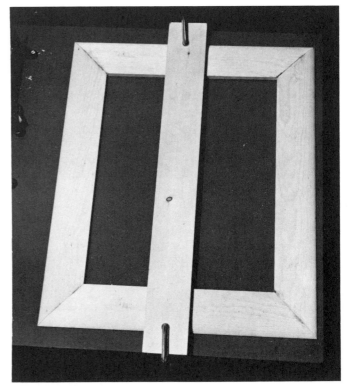

10 Drying. Clamping the frame face-up on the bench, allow the glue about an hour to set hard. A piece of 1 × 4 under the clamps distributes the pressure evenly and holds the frame flat.

The completed clamshell no. 1

Combining Insert and Clamshell

Follow these four easy steps and you can combine the clamshell you have just finished with a basic insert to create this distinctive silhouette.

As you can see, the insert is fastened to the face of the clamshell; therefore it is important to miter the corners of the rabbet strip instead of using the butt joints demonstrated earlier.

Tools. Hammer.

Materials. One inch (2.5 cm) brads, glue, clamshell frame, basic insert.

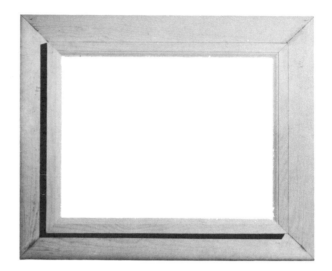

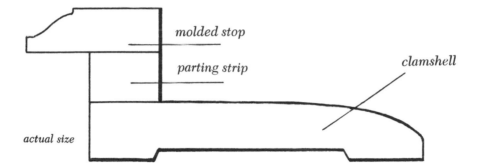

molded stop

parting strip

clamshell

actual size

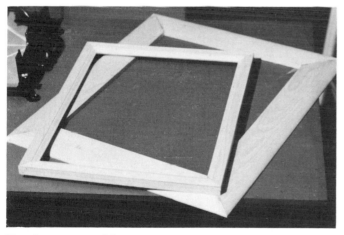

Ready to assemble

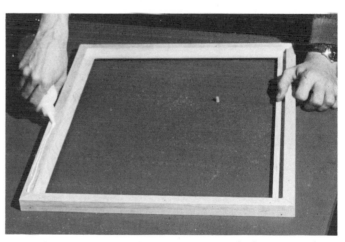

1 Gluing. We spread an even coat of glue over the back of the insert.

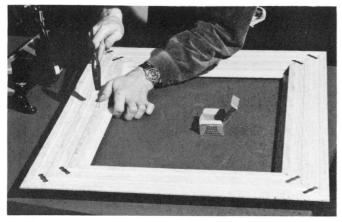

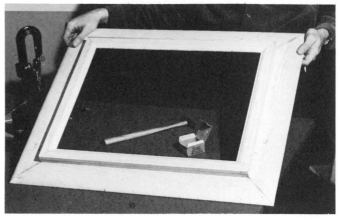

2 Temporary nailing. The clamshell frame is placed face-down on the glued surface of the insert, and its inside corners are lined up with the corners of the rabbet strip. We then drive a brad through each side of the clamshell partway into the insert.

3 Checking. The corners are checked from the front to see that the miters match, and the frame is ready to be permanently fastened.

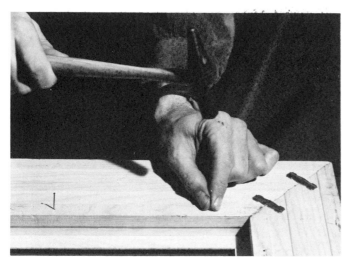

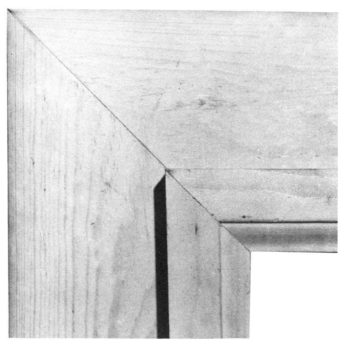

4 Permanent nailing. With the frame again face-down we are using brads to finish our assembly. Place them about 4 inches (10 cm) apart around the entire frame.

The completed frame

Clamshell No. 2

The narrow clamshell molding we use for this frame is the same design as the wide clamshell used in the preceding demonstration. Turning it on end and adding the basic insert creates a reverse frame of excellent proportions.

Tools. Miter box, backsaw, hammer, corner clamp, nail set, pencil.

Materials. Basic insert, one 10 foot (305 cm) piece clamshell (narrow), 1¼ inch (3.2 cm) brads, glue.

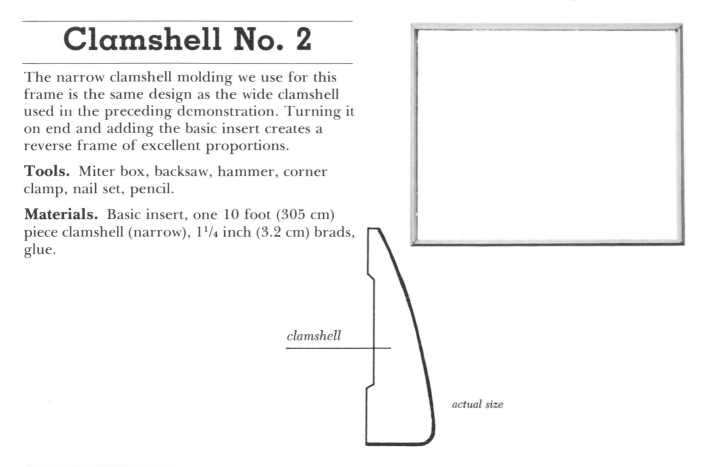

clamshell ———

actual size

◄1 **Cutting.** Holding the clamshell vertical against the back of the miter box, we make the first miter cut.

▲2 **Measuring.** We then use the insert as a pattern to mark the length of the first long side.

3 Cutting. Here we cut the second miter, completing the first long side.

4 Measuring. After repeating the first step, the first long side serves as a pattern to mark the second.

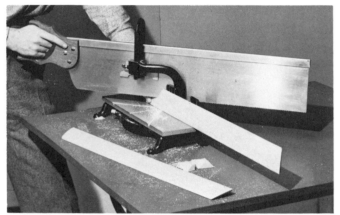

5 Cutting. Here we are making the cut that completes the second long side.

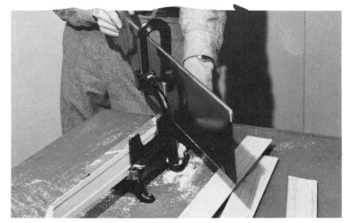

6 Cutting. Again using the insert as a guide, we have marked and cut the first short side of our frame. This final miter on the second short side completes the cutting.

7 Cutting completed

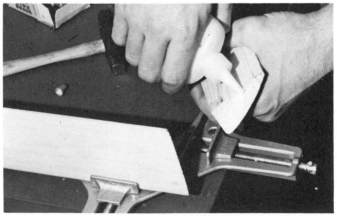

8 Gluing. Taking one short and one long side, we spread glue on the cut ends before placing them in the clamp.

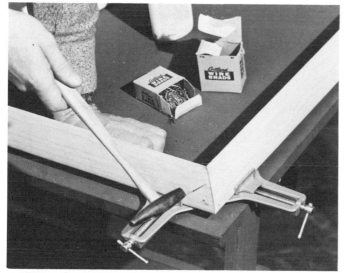

9 Clamping and nailing. With the clamshell tight in our clamp, we drive the first brad into one side near the top edge. (Don't drive the brads in all the way.)

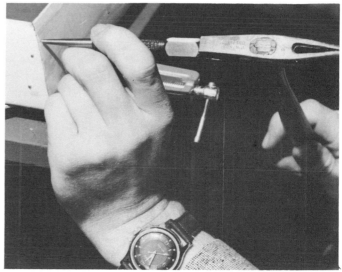

10 Setting. After driving two brads into each side we use our nail set to drive the brad heads beneath the surface, completing one half of our frame.

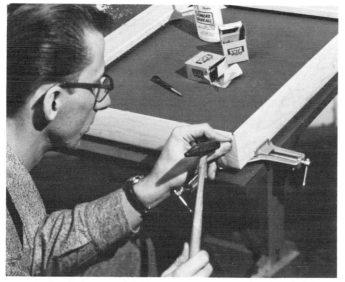

11 Joining. We repeated the previous step on the other half of our frame and are now joining the two halves in the same manner.

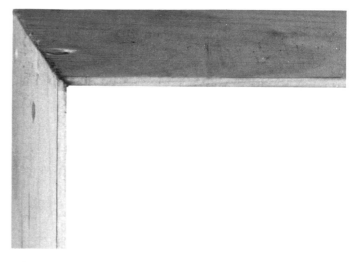

The completed clamshell no. 2

Combining Insert and Vertical Clamshell

A basic insert, the vertical clamshell frame, and these four easy assembly steps will give you a molding whose silhouette will work especially well with contemporary paintings.

Tools. Hammer, pencil.

Materials. Basic insert, vertical clamshell frame, 1 inch (2.5 cm) brads, glue.

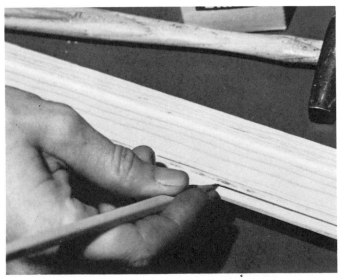

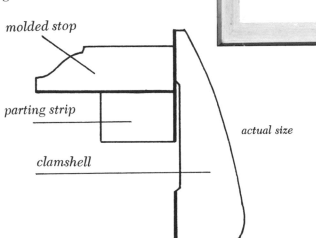

molded stop

parting strip

clamshell

actual size

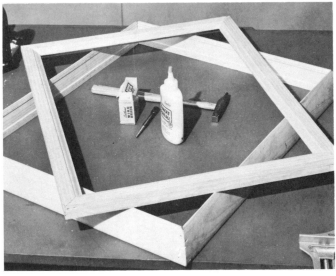

1 Ready to assemble. After trying the insert to make sure it fits inside the clamshell, we are ready to assemble the moldings. In this particular case our small plane was needed to trim the insert, which was a little too tight.

2 Marking. A pencil line about ¼ inch (.6 cm) inside the edge of the clamshell will guide us in positioning the insert.

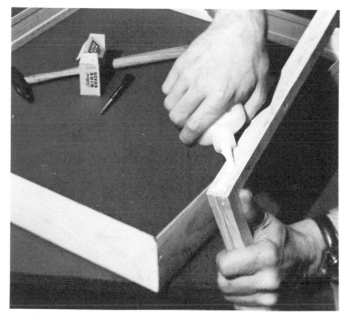

3 Gluing. We coat the edges of the insert fully and evenly with glue.

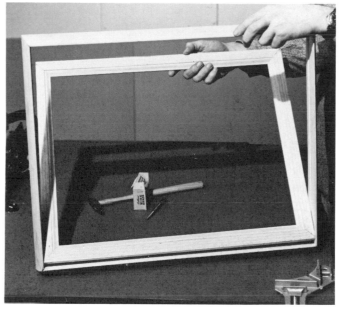

4 Positioning. Working from the back, we bring the insert up to the pencil lines.

5 Nailing. In the center of each side we drive a brad through the clamshell partway into the insert. Check the position, then brads about every 4 inches (10 cm) will hold.

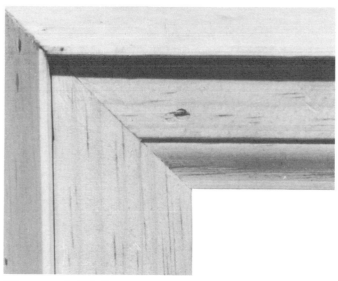

The completed frame

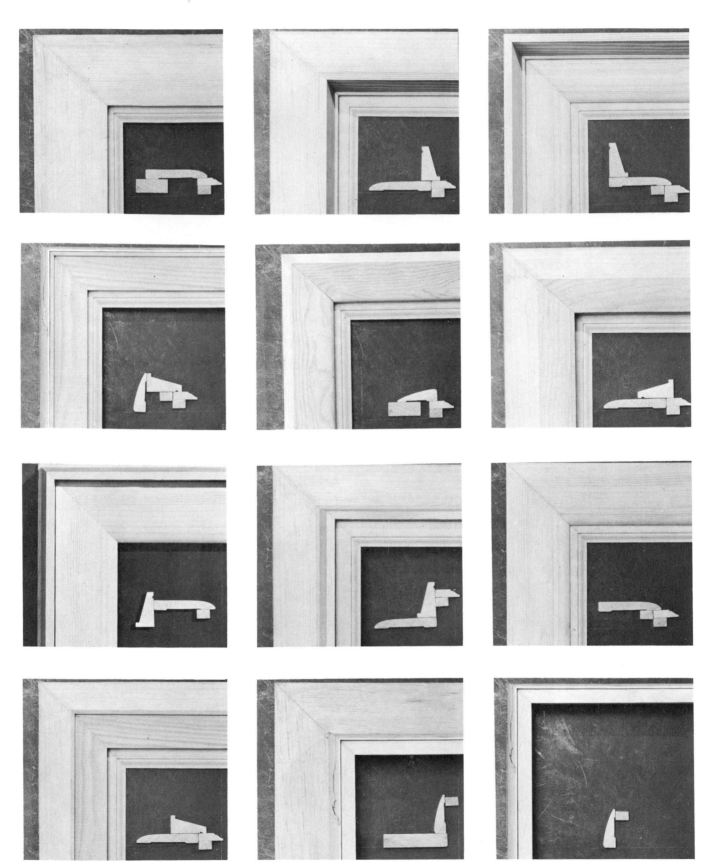

Some more combinations. *If you find this method of frame designing helpful, you might start a file of molding silhouettes, cutting off and saving ¼ inch (.6 cm) slices of each molding as you use it.*

Scoop Cove

A simple scoop is perhaps the most widely used frame molding profile. The builder's molding that most closely resembles this classic silhouette is called sprung cove. While it is a little tricky to handle because it has no large flat areas to keep it true in the miter box, the simple jig we show you here will enable you to cut exact miters when you have a picture that calls for this popular frame design.

Tools. Miter box, backsaw, hammer, corner clamp, C clamps, square, pencil, nail set, jig set-up.

Materials. One 8 foot (244 cm) piece sprung cove molding, glue, $1\frac{1}{2}$ inch (3.8 cm) brads, basic insert.

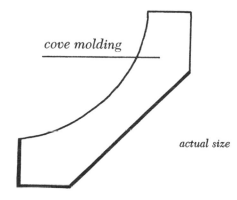

cove molding

actual size

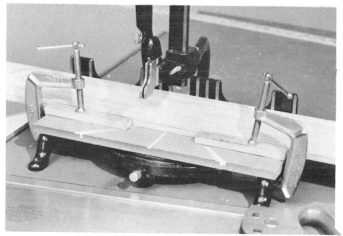

1 Jig set-up. Two pieces of parting strip clamped to the miter box will keep the molding flat against the bottom and back of the miter box.

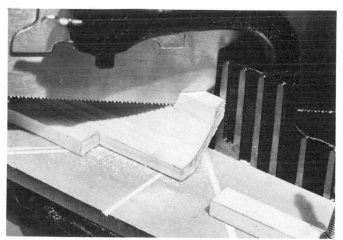

2 Cutting. We trim the end off our stock. In cutting this molding, the edge of the bottom of the miter box will be the edge that goes next to the picture. You can see how the strips of wood keep the molding in position, assuring a true miter.

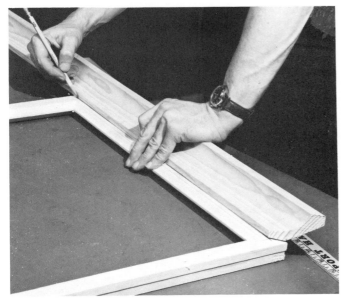

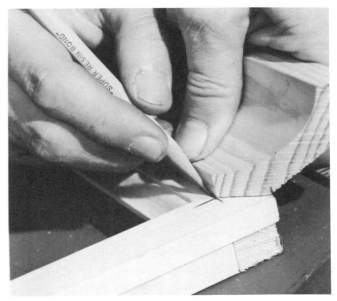

3 Positioning. To locate the cove molding on the insert, the flat bottom of the cove is aligned with the outside edge of the insert. We then mark all four corners in the same way. With the molding held in position we mark the length of the first long side. (See detail at right.)

Detail

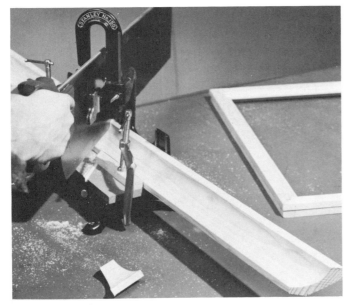

4 Cutting. We swing the saw to the opposite 45° angle and miter the other end of the first long side.

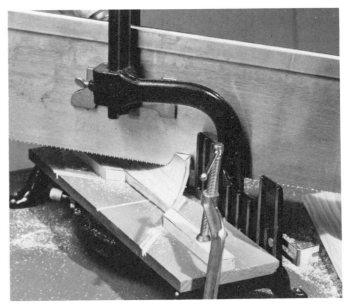

5 Cutting. Now we trim the end off our remaining stock—the first cut on the second long side.

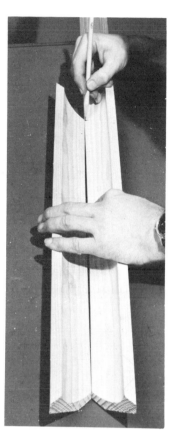

6 Measuring. Using the first long side as a pattern, we mark the second long side.

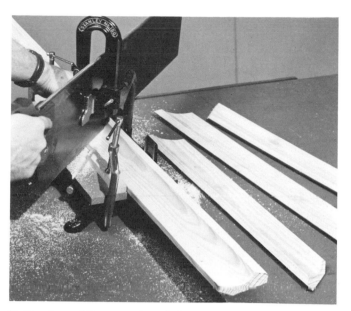

7 Cutting. We completed the two long sides and repeated the same steps on the short sides. Here we are making the final cut on the second short side.

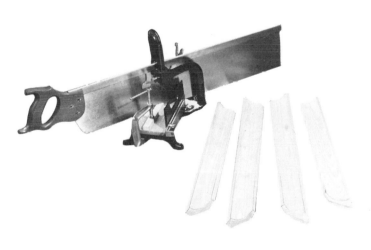

8 Cutting completed. The four sides of our frame are cut and we are now ready to tackle the tricky job of joining.

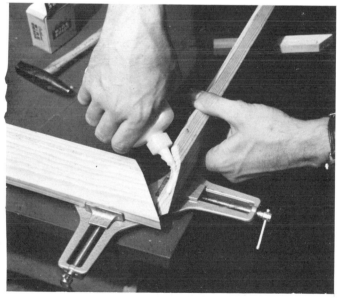

9 Gluing and clamping. Choosing one long and one short side, we spread glue evenly over the mitered surfaces. We have inserted the molding in the corner clamp upside-down to take advantage of the flat surface of the molding and also to bring our nailing surface up where we can see it.

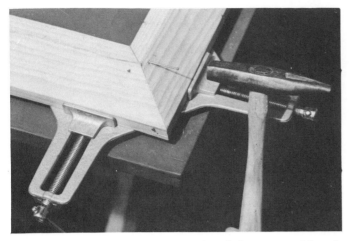

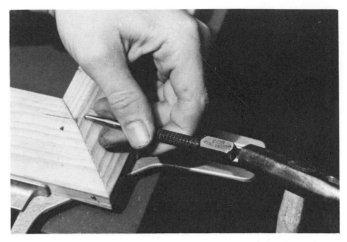

10 Nailing. After driving two brads into one side of the corner we now drive two more into the other. In this close-up you can see that the brads are not driven in all the way.

11 Setting. To complete this corner our nail set is used to sink the brad heads below the surface.

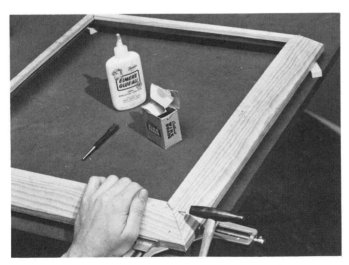

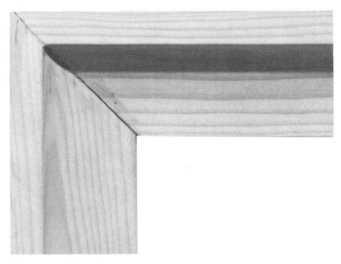

12 Joining. After repeating the three previous steps with the other corners of our frame, we are now driving the last brad in the final corner.

The completed scoop cove

Combining Insert and Scoop Cove

Of all the frames we demonstrate, this particular combination of cove molding and an insert would probably come closest to being what is popularly thought of as a "frame."

Tools. Hammer.

Materials. Scoop cove, basic insert, glue, 1 inch (2.5 cm) brads.

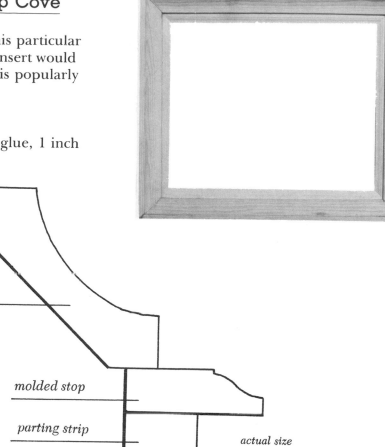

cove

molded stop

parting strip

actual size

1 Ready to assemble. The basic insert and our frame are ready to be fastened together. The frame is shown with the back facing up.

2 Gluing. We spread an even coat of glue along the entire back edge of the frame.

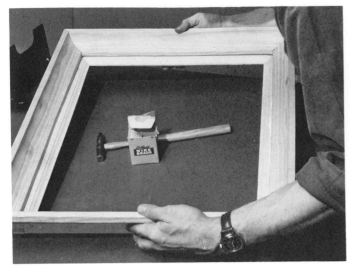

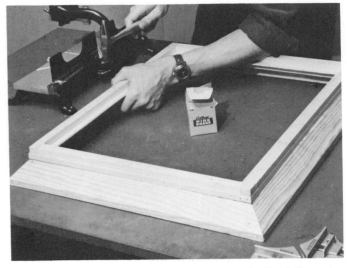

3 Positioning. After lining up the outside edge of the insert with the edge of the cove, we hold the insert in place and turn the frame over. We check to make sure the insert is positioned evenly within the frame before nailing it in place.

4 Nailing. Turning the frame so that the back is again up, we drive brads through the insert into the cove. About four to a side will do the job.

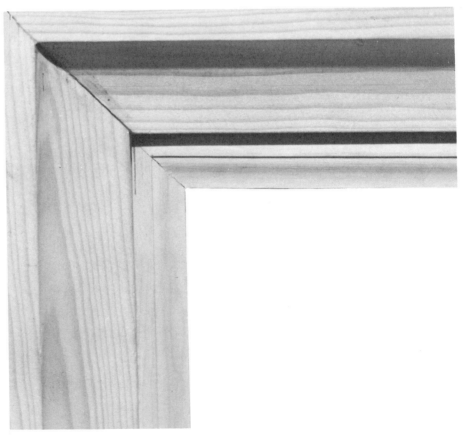

The completed frame

Reverse Cove

With sprung cove molding and the same jig we used in the previous demonstration, we can create an up-to-date frame with a classic flavor. This frame has all the good features of a modern reverse frame, and at the same time the character of the curved molding softens any severity. You'll find this design will work surprisingly well with a wide variety of pictures.

Tools. Miter box, backsaw, hammer, C clamps, nail set, pencil, jig set-up.

Materials. One 8 foot (244 cm) piece sprung cove molding, glue, 1½ (3.8 cm) brads, basic insert.

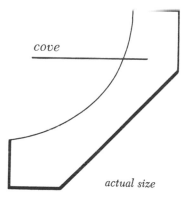

cove

actual size

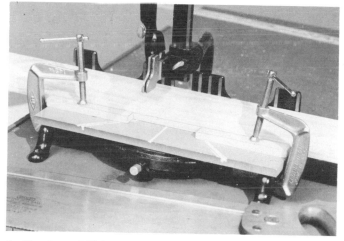

1 Cutting. With our jig set-up (above), we trim one end of stock. Note that in this case the edge against the back of the miter box is the one that goes next to the picture.

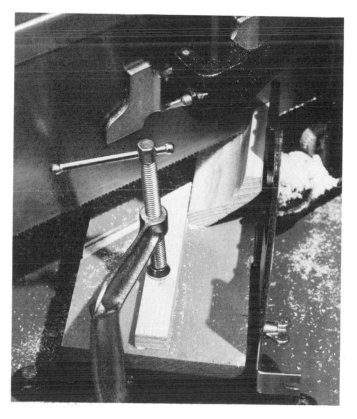

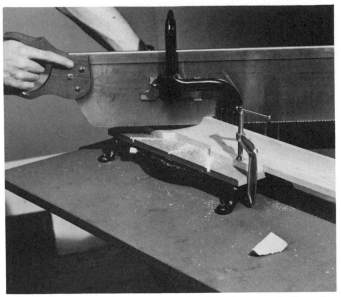

2 Measuring. Using the insert as a pattern we mark the first long side. Make this measurement very carefully; it is important that the molding fit around the insert exactly.

3 Cutting. We miter the marked end, completing the first long side.

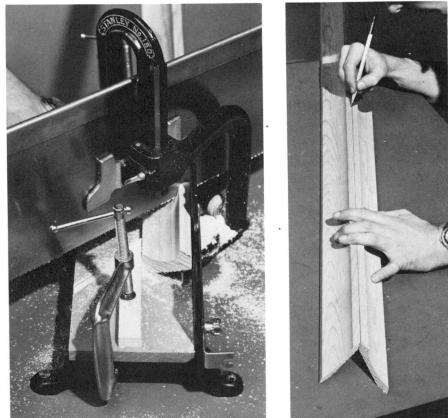

▶**4 Cutting.** With the first side cut, we trim the end of our remaining stock.

▶▶**5 Measuring.** Using the first long side as a pattern we mark the second long side.

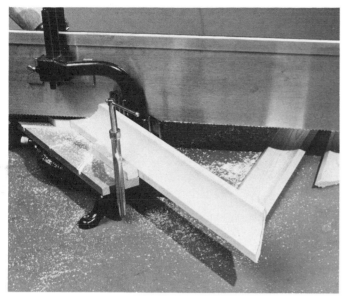

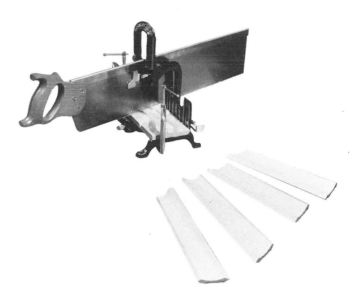

6 Cutting. After completing the second long side we repeat the same steps to make the short sides. Here the final cut is being made.

7 Cutting completed

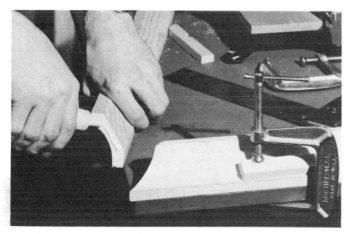

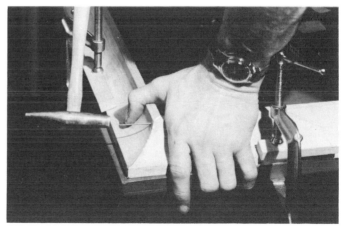

8 Gluing and clamping. Clamping one long side to the table, we apply glue to the end of a short piece. We then bring the two miters together and place a clamp on the short side; after checking the corner for squareness we tighten the clamps. Use a piece of wood under the clamps to protect the molding, and keep the clamps close to the edge to avoid twisting the frame. This is tricky—it took us two tries.

9 Nailing. Success! With both pieces clamped firmly in place we drive one brad into one side and two into the other. Don't try to drive the brads all the way in; you may scar your frame.

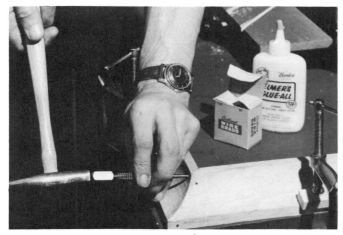

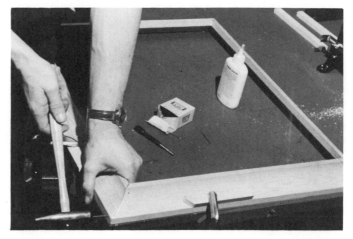

10 Setting. Using the nail set we sink the brad heads below the surface of the wood. This completes one half.

11 Joining. Repeating the same operation on the opposite half, we are now joining the final corner.

The completed reverse cove

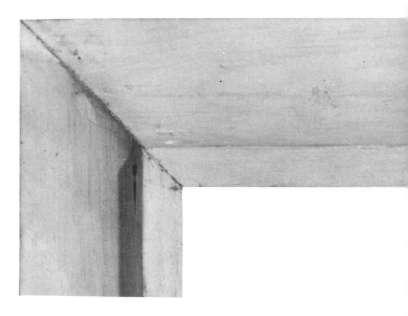

Combining Insert and Reverse Cove

A hammer, a few brads, and some glue are all you need to combine the reverse cove frame with a basic insert. In checking our insert with the frame we found the insert a little big—it happens to all of us at times—so a little had to be planed off one side of the insert.

Tools. Hammer, nail set.

Materials. Basic insert, reverse cove, 1½ (3.8 cm) brads, glue.

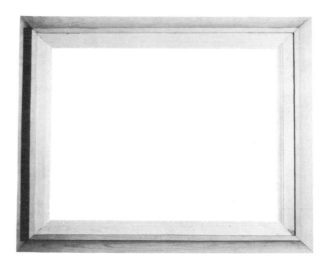

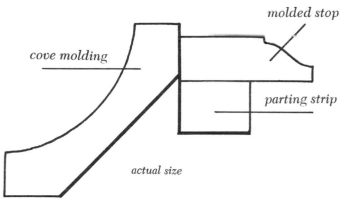

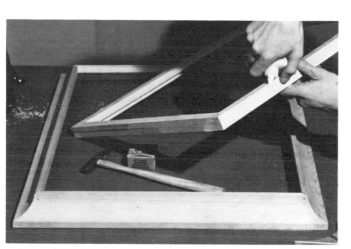

1 Gluing. We spread glue evenly on the surfaces to be joined.

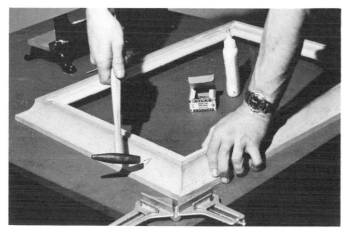

2 Nailing. We position the insert about ¼ inch (.6 cm) in from the top of the frame and drive brads in from the outside. Use the nail set for the final blows.

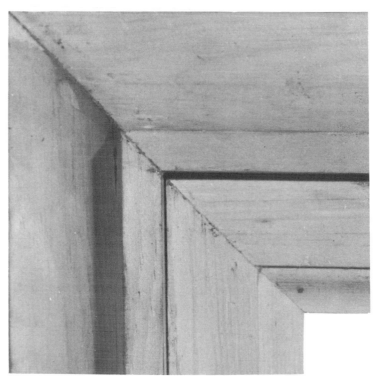

The completed frame

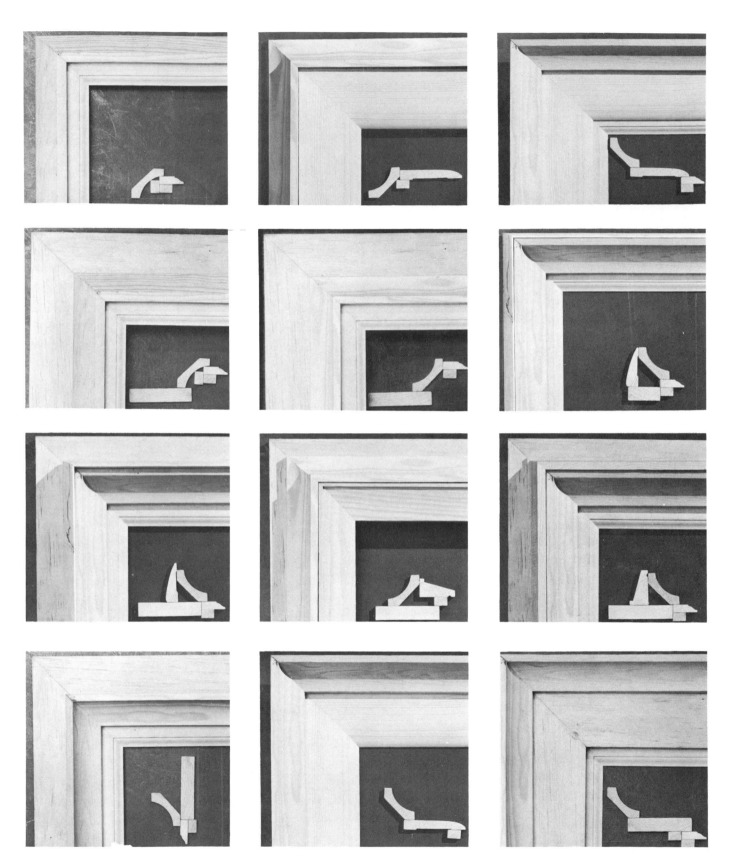

Still more combos. *By now you're really cooking. It's fun to put together ordinary moldings to create exciting-looking frames, but remember the frame should* always *play second fiddle to the picture. Keep in mind that it's a stepping-stone for the viewer, from the wall into the picture.*

Nose Cove

Up to this point we have shown you numerous ways to adapt standard moldings to create tasteful picture frames. We have turned them, stood them on end, and used them in various combinations. An additional way to utilize ordinary moldings is to cut a rabbet into one edge. For this demonstration we are using nose cove molding with a rabbet cut in the square edge. With a little experimentation you will find others which will also work with a rabbet.

If you own a power saw, you can cut the rabbet yourself; if not, your lumber yard will cut it for you. Take your book along and show them the first step.

Tools. Miter box, backsaw, hammer, corner clamp, table saw, yardstick, pencil, nail set.

Materials. One 8 foot (244 cm) piece nose cove molding, glue, 1½ inch (3.8 cm) 20-gauge brads.

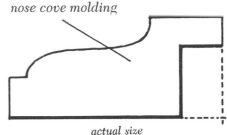

nose cove molding

actual size

▲1 Cutting the rabbet. First set your saw to make a ³/₄ inch (1.9 cm) deep cut; then with the guide set ¼ inch (.6 cm) from the blade, hold the molding horizontally and run it through. *Watch your fingers*—the rabbet should be in the *molding*. To complete the rabbet, set the saw for a ¼ inch (.6 cm) deep cut and the guide ³/₄ inch (1.9 cm) from the blade. Hold the molding as shown and make the cut.

▶2 Cutting. With the rabbeted edge of the molding against the back of the miter box, we cut our first 45° miter near one end.

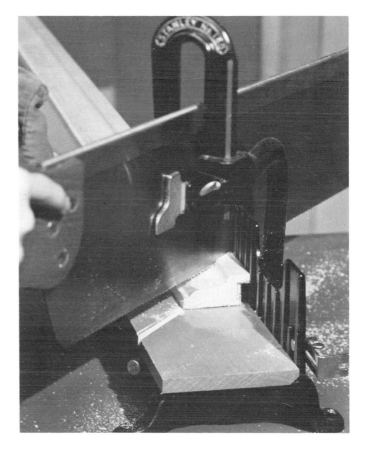

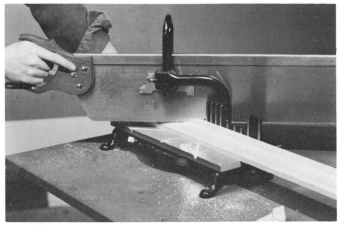

3 Measuring. Because we are not able to see the rabbet when we cut this molding, a little figuring is necessary to measure the length of the sides. Here is the procedure to follow: picture measurement + ⅛ inch − ½ inch (+.3 cm −1.3 cm). For example, our first side is 20 inches (50.8 cm), plus ⅛ inch (.3 cm) for play, minus ¼ inch (.6 cm) at each end for the rabbet; thus we mark 19⅝ inches (49.9 cm) on the inside edge of our molding.

4 Cutting. After swinging the saw to the opposite 45° position, and secure in the knowledge that we have measured correctly, we cut the second miter, completing the first long side of our frame.

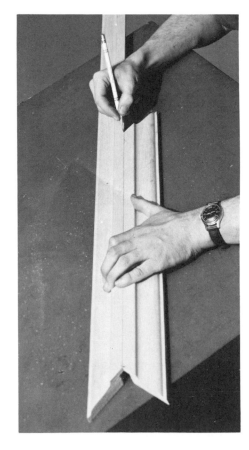

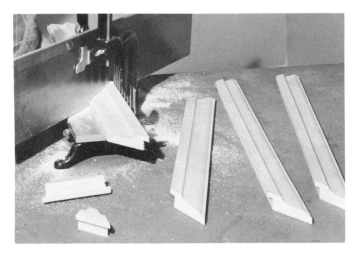

◀**5 Measuring.** We have cut off the end of the remaining stock, and, using the first side as a pattern, we are now marking the length of the second long side.

▲**6 Cutting.** Follow the same measuring procedure on the short sides—remember: picture measurement + ⅛ inch − ½ inch (+.3cm −1.3 cm). We are now cutting the final miter.

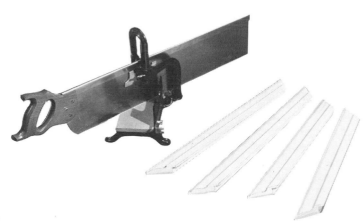

7 Cutting completed. The four sides are now ready for joining.

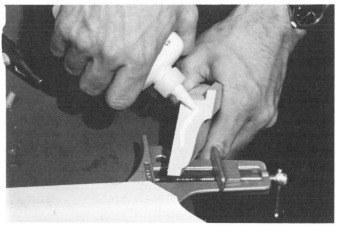

8 Gluing. Before clamping a long and a short side in the framing clamp we spread glue evenly on the miters.

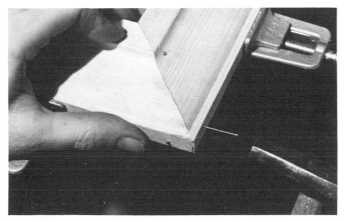

9 Nailing. In this close-up you can see that the brads are driven in only up to the head to avoid scarring the frame. We can use four 1½ inch (3.2 cm) brads and place them as shown for maximum strength.

10 Setting. Using the nail set we drive the brad heads below the surface of the molding.

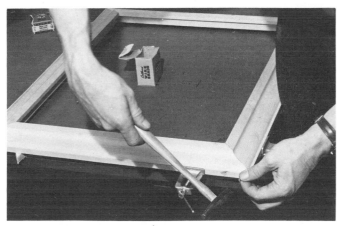

11 Nailing. We repeat the same joining operations on the opposite sides and are here joining the two halves. This final corner, when the brads have been set, completes our frame.

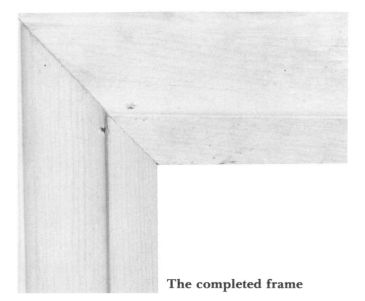

The completed frame

Brick

Brick molding makes an excellent frame when combined with a rabbet made of parting strip. Although it may be used with an insert as a frame for small oils, or in combination with other moldings for larger paintings, its simple profile works especially well with a mat as a frame for watercolors or drawings.

First build the parting strip rabbet to the dimensions of your picture. The brick molding will overlap it to hold the picture. Since the parting strip will not show, there is no need to miter the corners; simple butt joints will do nicely.

Tools. Miter box, backsaw, hammer, yardstick, corner clamp, nail set, pencil.

Materials. One 8 foot (244 cm) piece brick molding, one 8 foot (244 cm) piece parting strip, glue, $1\frac{1}{4}$ and 1 inch (3.2 and 2.5 cm) brads.

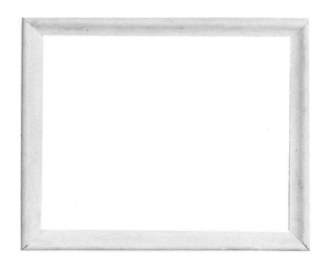

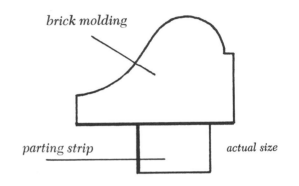

brick molding

parting strip actual size

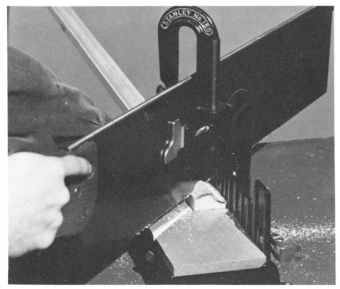

▲1 Cutting. First we trim off one end of our stock. Note that the thin edge of the molding is next to the back of the miter box. The molding will be held firmly in this position for all our cuts.

▶2 Measuring. Along the thin inside edge of the molding we measure the first long side. This measurement will be our picture measurement minus $\frac{1}{2}$ inch (1.3 cm) to allow for overlap.

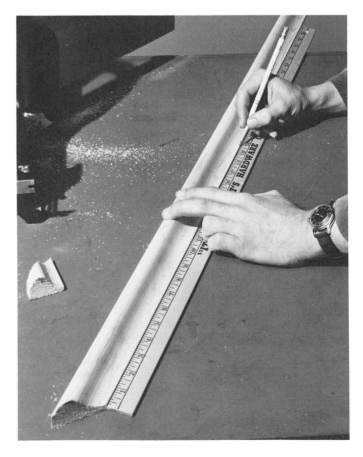

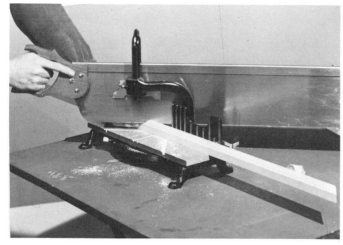

▲3 Cutting. We swing the saw and cut the second miter on the mark we have just measured.

▶4 Measuring. After trimming the end of our remaining stock we are here using the first side as a pattern to measure the second. Cutting a miter on this mark completes both long sides.

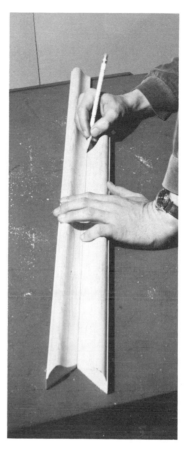

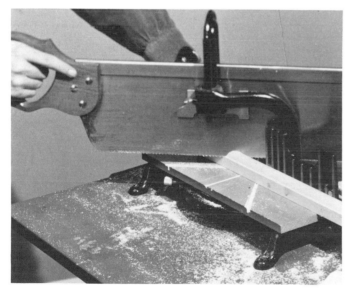

5 Cutting. We repeated the first four steps to make the two short sides; here the final miter is just about cut.

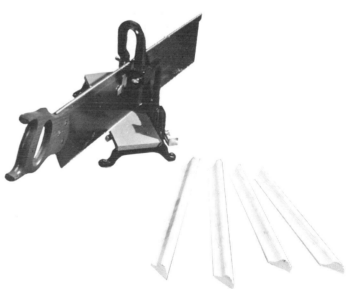

6 Cutting completed

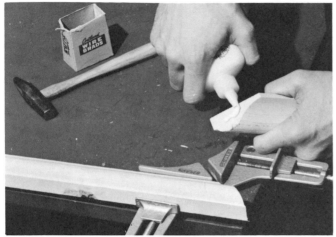

7 Gluing and clamping. We take one short side and one long side, spread glue evenly on the miters to be joined, and place the pieces in the clamp. Tighten both sides of the clamp evenly and firmly and the corner is ready for nailing.

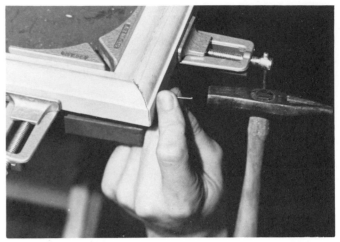

8 Nailing. With the pieces tightly held in the clamp we drive one 1 inch (2.5 cm) brad into each side. We hammer the brads in only up to their heads to avoid scarring the frame.

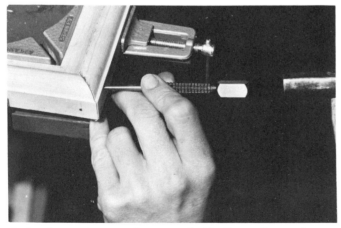

9 Setting. We complete one half of our frame by setting the brad heads below the surface.

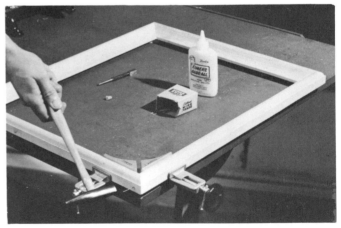

10 Joining. Repeating the previous three steps with the other two sides completes the second half. Here we are joining the two halves to complete the frame.

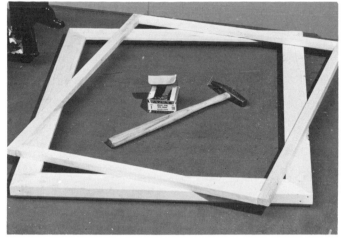

11 Ready to assemble

12 Nailing. With one 1¼ inch (3.2 cm) brad driven partway into each side, we check the position, and then nail the rabbet permanently to the frame with a brad every 4 inches (10 cm) around the strip.

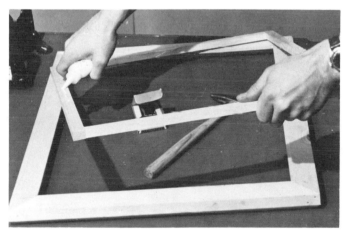

13 Gluing. We spread glue evenly on one face of the rabbet strip and center it on the back of our frame.

The completed frame

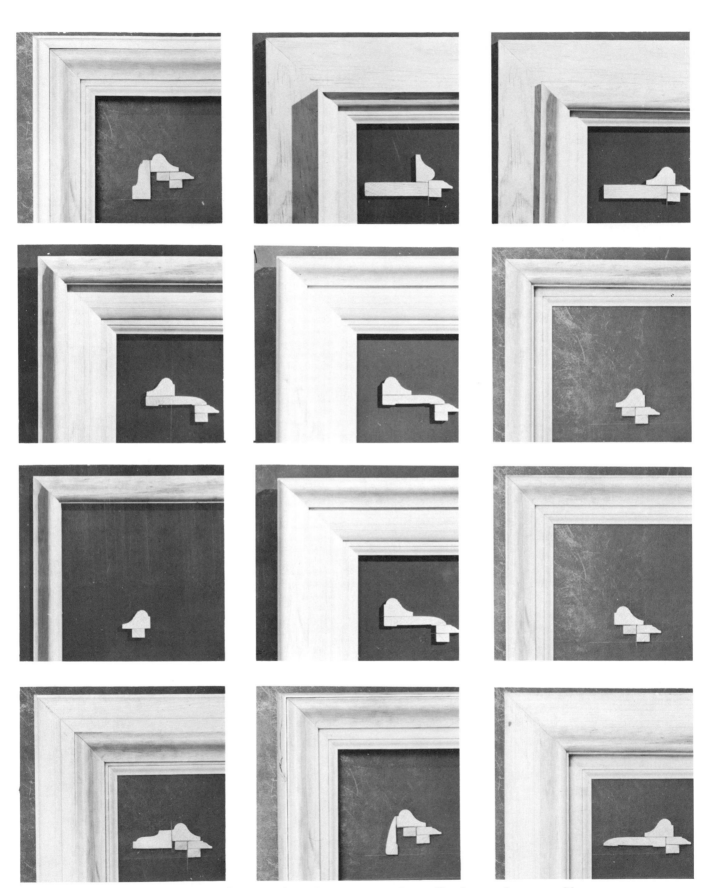

Another look: *Again, just two or three simple moldings can make really elegant frame profiles.*

Strip Frame No. 1

The strip, or band, frame is a comparatively new design which came into popular use about the time Mondrian was exhibiting his geometric compositions. Its clean lines complement the functional design of most contemporary paintings.

Here is a simple way to build a permanent strip frame for pictures painted on panels of Masonite® or wood. It consists of two wooden rectangles: one made of parting strip, which is fastened to the back of the panel, and one made of lattice strip, which goes around the panel and forms the frame proper.

Tools. Miter box, backsaw, corner clamp, four C clamps, hammer, pencil, nail set.

Materials. One 8 foot (244 cm) piece 1³/₄ inch (4.5 cm) lattice strip, one 8 foot (244 cm) piece parting strip, glue, 1 inch (2.5 cm) brads.

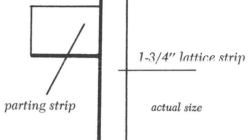

parting strip *1-3/4" lattice strip*

actual size

1 Measuring. Using the panel as a pattern we measure the first long side of the parting strip.

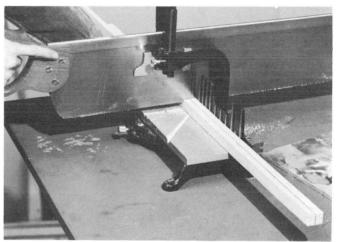

2 Cutting. Because we are using simple butt joints on our backing strip, we are cutting both long sides at the same time to ensure getting them exactly the same length.

3 Measuring. Holding the two sides we have already cut as shown, we again use the picture as a pattern to measure the short sides of the backing strip. Cut the sides and assemble the strip as shown on page 27.

4 Positioning. After assembling the parting strip backing, we position it on the back of the painting and draw a line around the inside edge. Then we begin cutting the frame proper.

5 Cutting. The lattice strip is held vertical in the miter box, and we trim the end, cutting our first 45° miter.

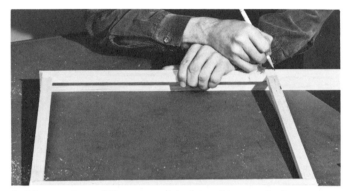

6 Measuring. The assembled backing strip becomes the pattern with which we are measuring the first long side of our frame.

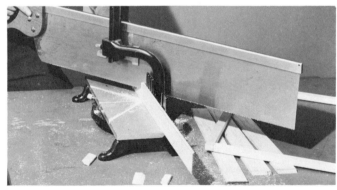

7 Cutting. We have cut both long sides and repeated the same steps to make the short sides. Here we are cutting the final miter.

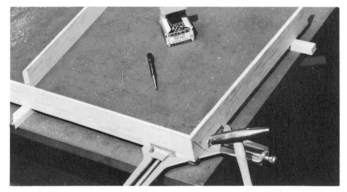

8 Joining. Joining these two halves and setting the brads completes the strip, and we are ready to fasten the backing to our picture.

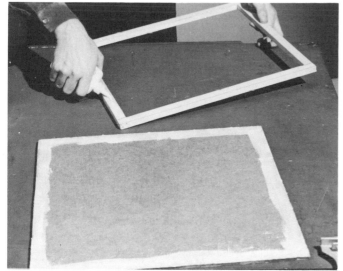

9 Gluing. Using the pencil line as a guide we coat the back of the panel evenly with glue. One side of the parting strip is also coated evenly with glue; both are allowed to dry and then given a second coat of glue over the same areas.

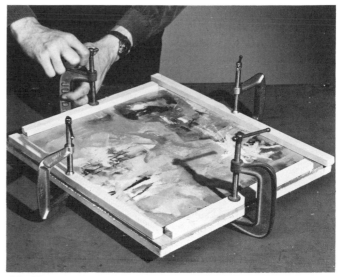

10 Clamping. While the second coat of glue is still wet we position the strip, and clamp the two surfaces firmly with the C clamps. Be sure to use scrap pieces of parting strip to protect the painting and to spread the clamp pressure evenly along the edge of the panel.

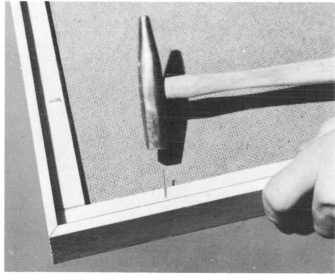

11 Assembly. After the parting strip and panel are dry—ours took about an hour—we fit our frame around it. With the picture face-down on a level surface and working from the inside, we toenail 1 inch (2.5 cm) brads through the parting strip into the strip frame.

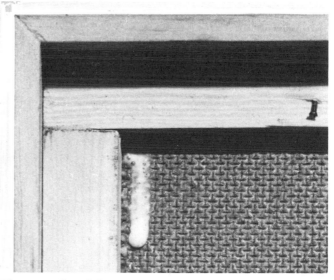

The completed frame
back view

Strip Frame No. 2

An ordinary 1 × 2 inch (2.5 × 5.1 cm) strip of wood can easily be made into a molding particularly suitable for band or strip frames. If you have a power saw, three simple cuts and you are ready to begin framing. If not, your lumber yard can convert the strip for you by following the first two steps.

The main difference between this and an ordinary strip frame molding is a 30° chamfer which adds a bit of depth and enhances the proportions of the molding.

Tools. Miter box, backsaw, hammer, corner clamp, table saw, nail set.

Materials. One 8 foot (244 cm) piece 1 × 2 inch (2.5 × 5.1 cm) stock, glue, 1¼ inch (3.2 cm) brads.

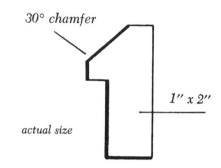

30° chamfer

1" x 2"

actual size

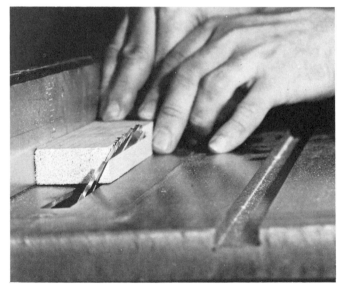

1 Ripping. Setting our saw at the 30° mark, we adjust the guide so that we don't cut completely across the edge; the ⅛ inch (.3 cm) left flat will provide an interesting accent to the angle created by the chamfer.

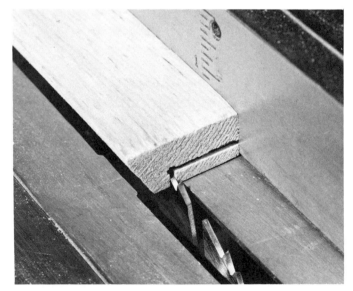

2 Ripping. Returning the saw blade to the 90° position we set it for a 1-inch deep (2.5 cm) cut. With the guide set ¼ inch (.6 cm) from the blade, run the strip through. Then as you see in the photo, the blade is set for a ¼-inch-deep (.6 cm) cut. With the guide ¼ inch (.6 cm) from the blade, run the strip through to complete the rabbet.

3 Cutting. To begin making our frame we cut the first 45° miter near one end of our stock. Notice that the flat side of the molding is held firmly against the back of the miter box.

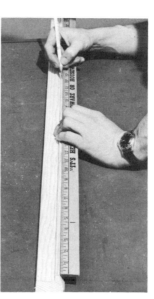

4 Measuring. From the inside of the miter we measure the first long side.

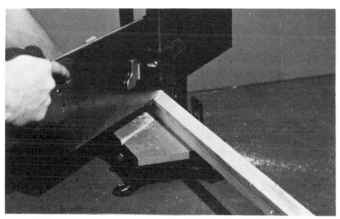

5 Cutting. We swing the saw to the opposite angle and make the cut, completing the first long side.

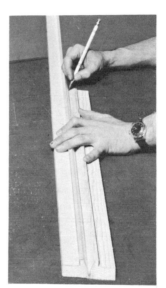

6 Measuring. After repeating the first step to trim our remaining stock, we use the first side as a pattern to mark the second.

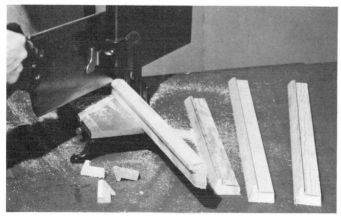

7 Cutting. Using the same measuring and cutting procedure that we used on the long sides, we are here making the final miter cut.

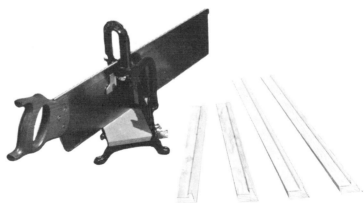

8 Cutting completed. What started as a simple 1 × 2 inch (2.5 × 5.1 cm) strip of lumber is now the four sides of our frame.

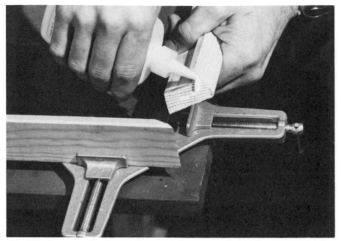

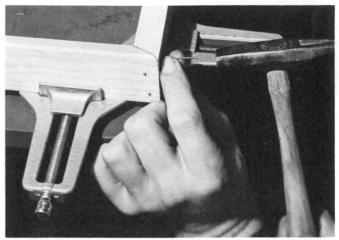

9 Gluing and clamping. After coating the mitered ends of one short and one long side of our frame, we tighten them firmly in the corner clamp, ready for nailing.

10 Nailing. We drive two brads into each side of the corner, making sure to leave the heads exposed; use your nail set to avoid scarring the frame.

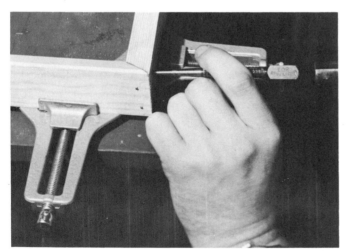

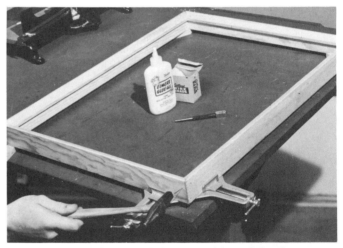

11 Setting. With a nail set we drive the brad heads below the surface of the wood, completing the first half of our frame.

12 Joining. The remaining two sides of the frame are joined in the same manner as the first, and then the two halves are joined together to complete the frame.

FINISHING

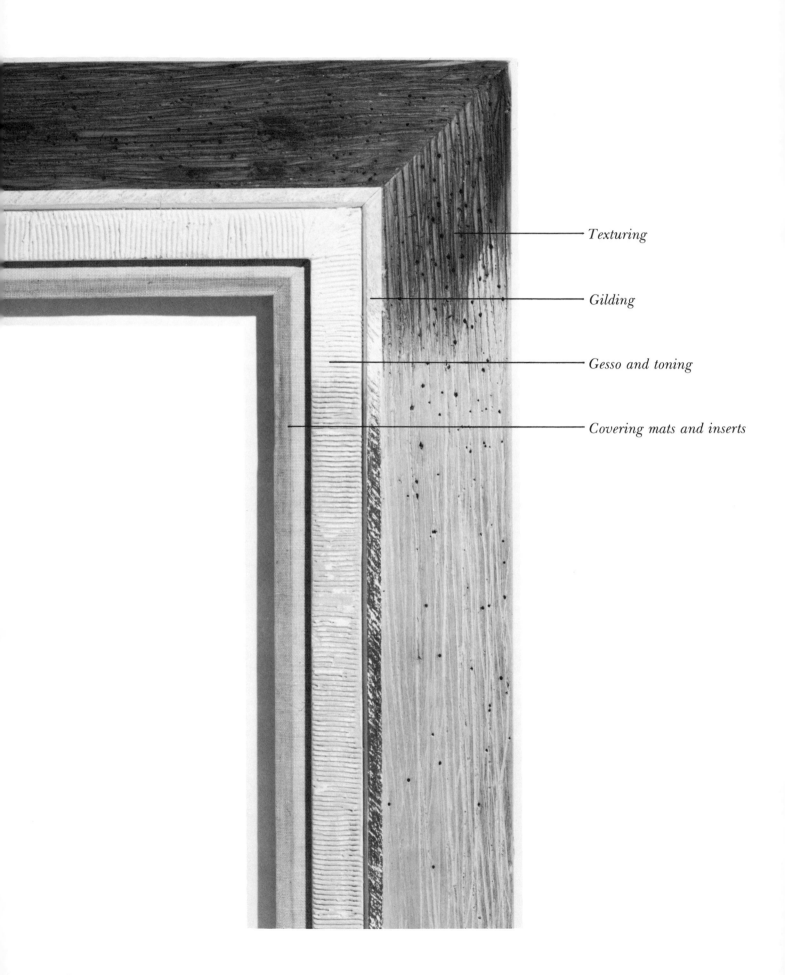

Texturing

Gilding

Gesso and toning

Covering mats and inserts

Finishing Your Picture Frames

All the frames you build with carpenter's molding will need to be finished, since raw wood with a strong grain pattern will rarely complement your pictures.

There are many ways to finish your picture frames. The possibilities are limited only by the range of your imagination and the time at your disposal. All of the finishes, however, are based on a two-step process. First the frame is textured, then it is toned to harmonize with your picture.

One way of texturizing a frame we call "cutting in." The second method we call "building up." The cutting in can range from a simple sanding to complex carving of the surface of your molding. Building up uses the frame molding as a base upon which to build a textured surface. The texture can extend from a simple thick coat of paint or gesso all the way to a complicated sculptured, rococo-type molding complete with roses and cupid's bows. Beautiful modern finishes can be created using simple variations of both texturing methods either singly or in combination. On the following pages we demonstrate how you can prepare the surface of your frame for finishing in any number of ways.

Whether we carve our texture or build it up, the final finish of our frame will depend on color to present the picture at its best. Color or tone is usually applied to a frame in one or more coats of paint, called patinas. The patina is basically gray but it may be tinted slightly with other colors. The color, however, should never be so strong as to overpower the picture. Neutrality is a good word to keep in mind when you mix any color for toning a frame. A good finish should harmonize with the picture; at the same time it should separate it from busy surroundings—but it must do all these things unobtrusively.

Before you actually start to work on your frame, read all the information on the following pages so that you get an idea of how this can be achieved. Then follow the step-by-step demonstration, mix a batch of basic patina, and you are on your way in one of the most creative and exciting phases of picture framing.

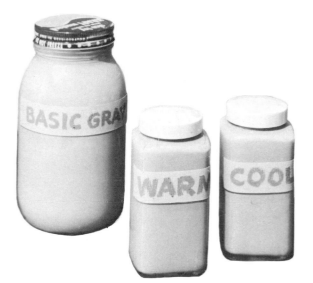

Patinas

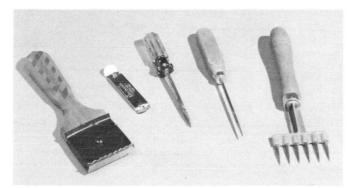

Texturing

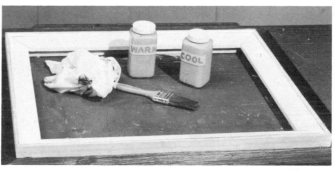

Toning

Mixing Patinas

It used to be that the base of any patina was a thinned gesso. Anyone who has gone through the cookery necessary to make gesso can understand the joy some of the new paint products have brought to people who frame pictures. For our patinas we use one of the vinyl-base household paints. It is readily available, water soluble, and easy to mix, and brushes can be cleaned merely by rinsing them under the faucet. It dries quickly into a hard, waterproof, and lasting surface.

Any water soluble artist's colors such as casein or poster colors can be used to tint your patinas. The tinting colors we use are called Universal Colorants because they may be used to tint either oil or water-base paint. Raw umber, ivory black, yellow ochre, ultramarine blue, and iron oxide red are all you will need for most finishing jobs.

Basic Gray

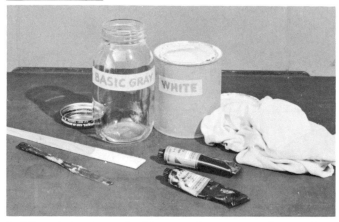

1 Materials. Our vinyl-base paint, raw umber and black colors, a jar, some rags, a mixing stick, and we're ready to begin. For clarity in our photographs we are working on a painted table top; however, as we proceed you will see that a good supply of newspapers is normally a must.

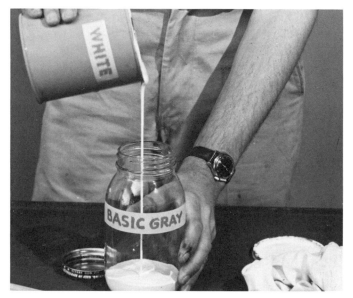

2 Base color. We start by pouring a quantity of the white into a large jar. The paint should be about the consistency of honey. You can thin it slightly with water if necessary.

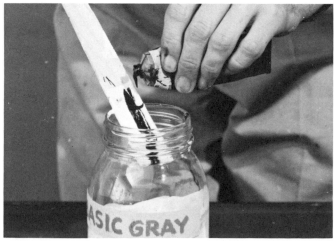

3 Adding color. We add enough black to make a gray approximating the value of the gray tint at right. This gray will be too cool, so we will add enough raw umber to get a more neutral tone. From this basic gray we will mix two patinas—one warm and one cool.

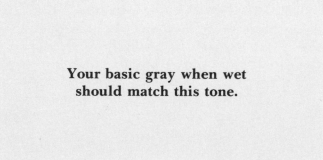

Your basic gray when wet should match this tone.

Note: It is difficult to give exact quantities of color to use in mixing because the tinting strength of tube colors varies. However, one of the advantages of this type of finishing procedure is that should you get it too light or too dark, too warm or too cool, it can be easily adjusted with another coat of patina.

Mixing warm and cool patinas

In most cases a frame is richer looking if its tone is built up with two or more patinas of varying color and temperature. The play of warm against cool, light against dark, enhances the texture of the frame, and the vibrancy created avoids a flat "painted" look. Coffee cans and frozen-food containers make excellent disposable mixing bowls. TV-dinner trays divided in sections are especially handy for mxing small quantities of patina to finish a single frame or for making subtle adjustments in tone or color of a patina. The jars we use to store our patinas in are 8 ounce (24 cl) powder jars available in any drugstore.

Materials. Basic gray patina, two 8 ounce (24 cl) powder jars, yellow ochre, iron oxide red, ultramarine blue tinting colors, rags.

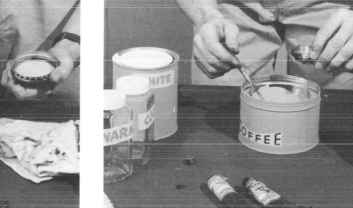

1 Base color. We pour a quantity of our basic patina into the mixing bowl.

2 Adding color. For a warm tint we add a small amount of yellow ochre to the basic patina. The color is too intense so we add enough red to kill the yellowness. The final patina is a warm brownish gray slightly darker in value than the basic gray.

For the cool patina, add a *small* amount of ultramarine blue to a quantity of basic gray. Use the blue sparingly; you may find it necessary to add a bit more raw umber to gray the patina to a more neutral color.

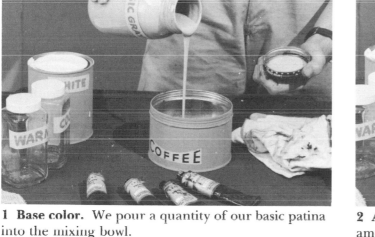

3 Filling. When the colors are satisfactory, we pour each one into its jar labeled "warm" or "cool."

Patinas. Here are our patinas, ready to use. If you intend to finish frames from time to time, mix up a good quantity of these three patinas. They provide a basic "palette" which has endless possibilities for varying the finishes of your frames to complement any picture.

Cutting In Texture

Now that we have our patinas mixed and ready to use, we are ready to take the first step in finishing an actual frame. Using the drip cap frame we demonstrated on pages 33–36, we will show you two ways of cutting in textures. Keep in mind as you work, however, that these procedures will work with any frame. Read over the methods we use and then follow the steps. It won't be long before you are finding your own variations and creating exciting finishes for the frames you build.

Tools. Paint scraper, palette knife, wood rasp, triangular file.

Materials. Wood filler, sandpaper.

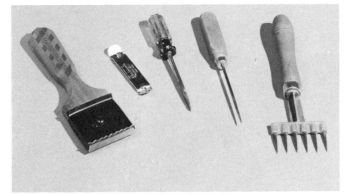

Raking Tools. We call the first cutting in method we show you "raking" because we actually rake the surface of our frame. You can use any sharp, pointed instrument to cut the texture into the wood; however, we recommend the paint scraper as the easiest and most effective.

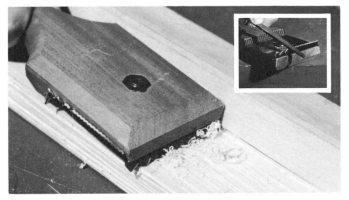

Creating a rake. To convert the paint scraper into a texturing rake we file a series of V-shaped teeth into the edge with our triangular file. Keep the teeth uneven; too much regularity will make the texture monotonous. In the close-up you can see how the teeth of the rake dig into the wood. Notice that the texture is not mechanical or regular.

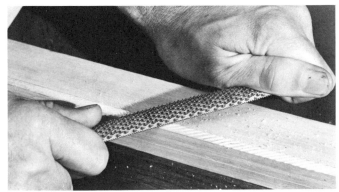

Rasping. The second texturing method requires only our wood rasp. The rasp is held flat and pushed diagonally across the surface creating a series of ridges. Caution: *work lightly*. Too much pressure will break down the edge of your frame.

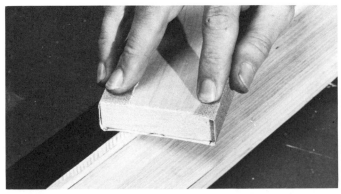

Sanding. Sanding completes the texturing methods we are going to use to cut into the surface of our frame. We are now ready to show you how to create a texture on the surfaces of the drip cap.

Cutting In

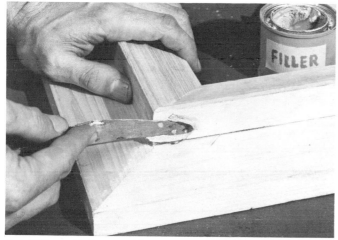

1 Filling. Before raking the surface of the 1 × 4, we fill the nail holes with wood dough, which we force into the holes with a palette knife. Press hard to make sure the holes are solidly filled. If there are any small gaps in the mitered corners, fill them also.

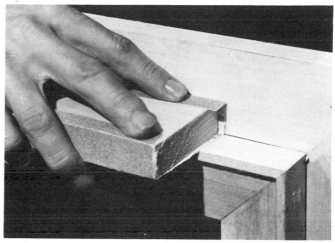

2 Sanding. Excess wood dough can be sanded off when dry—in about 10 or 15 minutes.

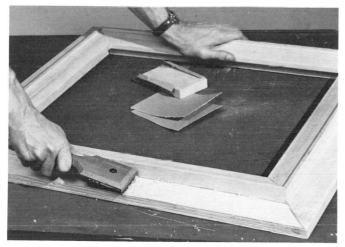

3 Raking. We use the paint scraper to rake the surface, making a series of valleys. Rake *with the grain* from the miters toward the center with short, firm strokes—the more grooves the better. Try to keep the texture from becoming too uniform.

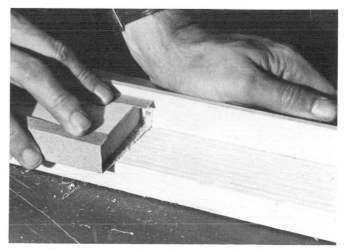

4 Sanding. After raking the entire 1 × 4 we sand the surface lightly to remove the heaviest burrs. This is not a finished sanding and should not be too smooth.

Building Up Texture

The basis of this method of texturing a frame is very simple: a coat of paint, into which the texture is scored, scratched, or modeled.

Building up a texture used to mean applying many coats of gesso or thick casein paint. The first is an involved, time-consuming process, and the second, while quicker, has the annoying property of chipping or flaking off.

Looking for a way to build up textures with all the good points of gesso and none of its complexities, we found that the same vinyl paint we used to mix our patinas worked perfectly when we used it in its undiluted form.

We also experimented with another product, which was originally developed for the building trade, wallboard compound. Used directly from the container and thickly buttered on with a putty knife, this material will result in an even stronger texture when combed. It is inexpensive, and dries quickly and hard. It holds well, shrinks very little, and can be easily sanded. It can even be used as a filler, like plastic wood or wood dough, to hide imperfections. Look for it in building supply or paint stores.

Here we are working on the drip cap frame.

Other texturing tools. Look around your home; almost anything that can make a mark will serve as a texturing tool. Experiment with everything from your fingers to a piece of window screening.

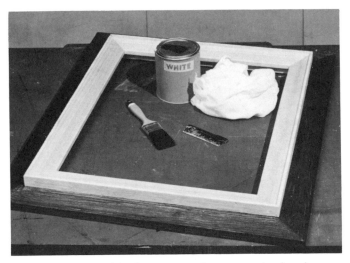

Materials. For this demonstration, our vinyl paint, a nylon brush, and a pocket comb are all we need.

Building Up

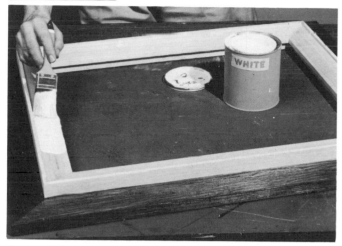

1 Applying gesso. We brush on a thick coat of our vinyl paint "gesso." This must dry 10 to 20 minutes or until the paint will retain a scratch without filling in.

2 Painting insert. While the gesso is drying we give the insert a coat of the white vinyl. You may find a little water is needed to thin the paint to an easy brushing consistency.

3 Combing gesso. We break the comb in half to make it easier to handle and, working from the outside edge, draw it quickly across the partially dried paint. Continue combing until the whole surface of the drip cap is textured to your satisfaction.

Textures. Here are two textures easily created with a comb. The first is made by scoring the paint once with the coarse teeth of the comb; the second is made with several passes of the comb over the surface. How much texture you should make depends on your own taste and the requirements of the picture you are framing. Remember that the frame *must not compete* with the picture for the viewer's interest.

Toning

Staining

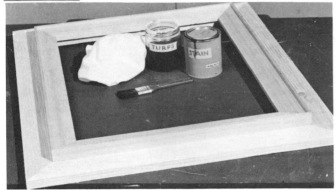

1 Ready for staining. With the surface raked and sanded we are ready to stain this 1 × 4.

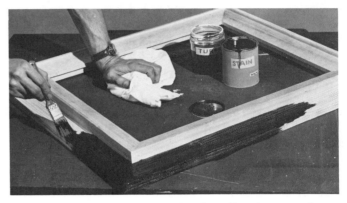

2 Staining. We now brush in the oil stain, covering only the surface and edges of the 1 × 4.

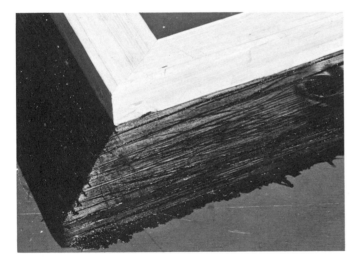

3 Close-up. Notice how the stain soaks into the wood. We use a deep shade such as walnut to provide a permanent dark value which we will then use to control the final tone of our frame. Drying time varies, so follow the manufacturer's recommendations. It is important that the frame be *thoroughly dry* before proceeding.

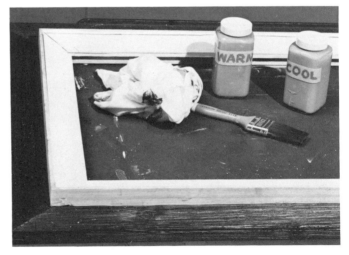

Toning. Our frame is textured: the 1 × 4 is raked and stained, the molding's "gesso" is dry, and we are now ready to use the warm and cool patinas in the final stage of finishing.

Applying Patinas

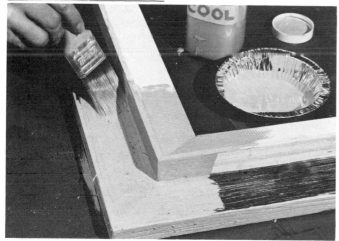

1 First patina. We use the cool patina first because we want to finish with a warm tone to go with the warm quality of the picture we are framing. If our picture were cool in tone we would use the warm patina first. Thin the patina slightly with water and brush well into the valleys.

2 Sanding. After the patina is dry—in about 25 or 30 minutes—we sand the whole frame with medium sandpaper—enough to show some of the dark understain on the ridges but not enough to dig the patina out of the valleys.

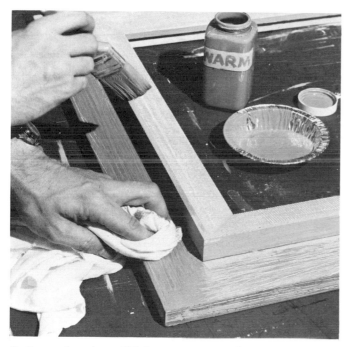

4 Sanding. The last sanding controls the final tone; the more patina you take off, the darker the value of the finish.

3 Second patina. With our warm patina we now cover a small section of the frame. Before this dries we wipe it lightly with a rag, exposing the first patina and some of the understain. We repeat this process around the whole frame as many times as is necessary to arrive at the tone we want.

Note: Now is a good time to try the frame on our picture. If the frame is too dark because we have sanded too much, we give it another coat of warm patina, wipe it lightly, and sand again. With successive coats of light and dark, warm and cool, you can achieve any color or value to harmonize with any picture.

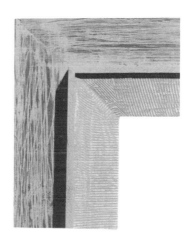

Gilding

As with anything in framing, there are many ways to give your frames a touch of gold. Here are four methods of gilding you can try. Each has its own characteristics. Experiment with all of them to find out what they are like and how you can use them in finishing your frames. Gilding is fun and it won't be long before you are finding your own creative uses for this fascinating phase of picture framing.

The first method is the simple procedure explained on this page. It's quick, direct, and works especially well for small areas of gold accent. The next two gilding methods use metal leaf. First, pure 23 carat gold leaf on a paper backing; this is expensive, but we recommend it because of its ease in handling. The synthetic leaf is a little harder to master, but as you gain confidence you will probably use this less expensive material for most of your frame gilding.

For a really quick gilding job try the wax gilding method. You will be well pleased with the richness of this simple process.

Tools. Gilder's tip.

Materials. Gold leaf, gold size, white shellac, our warm patina, vinyl white, colorants, steel wool, absorbent cotton, Venus bronzing powder, paste wax, TV-dinner tray, rags.

The Simplest Way

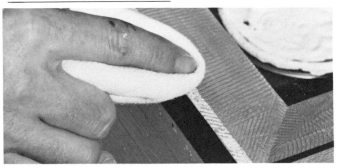

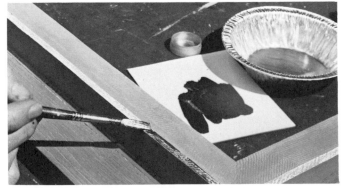

1 Whiting edge. Since our frame is the right tone we now dress it up by dipping a small pad in the undiluted white vinyl paint and wipe it quickly along the raised edge of the drip cap. Drag the pad lightly; don't try to fill the grooves solidly.

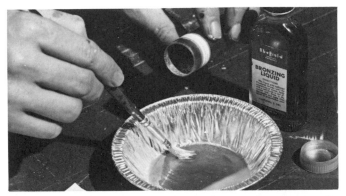

2 Mixing gold. We have poured a small amount of bronzing liquid into a pan—a frozen-food container serves well—and we add enough Venus powdered gold to make a mixture of good brushing consistency.

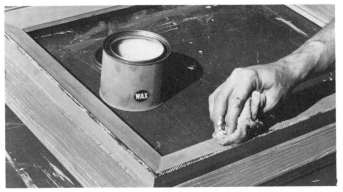

3 Applying gold. We work some of the gold out of our brush into a scrap piece of cardboard or newspaper before applying it to the frame. Working quickly, we "dry-brush" the edge, just hitting the high spots. This touch of gold, if not overdone, will give our frame richness.

4 Waxing. Over the thoroughly dry, finished frame we rub a coat of paste wax. The wax is to protect, not polish, the finish, and its satinlike sheen serves to pull the tone together into a mellow antique patina.

The Real Thing: Gold Leaf

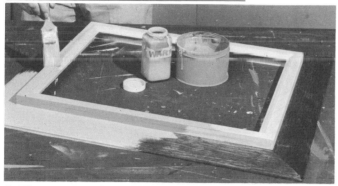

1 First patina. We first give the entire frame a coat of warm patina. Note that the clamshell flat has already been raked and stained. We are going to leaf the inner face of the insert.

2 Steel wooling. After the patina dries we lightly steel wool the surface to be gilded.

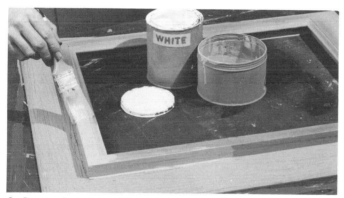

3 Second patina. To our warm patina we add enough white to lighten it and coat the insert again.

4 Steel wooling. A second steel wooling leaves the surface smooth enough for a good gilding. Repeat the patinizing and steel wooling as many times as is necessary to provide a smooth surface.

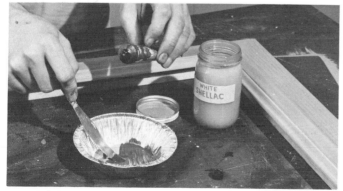

5 Mixing shellac. Metal leaf always looks better when it is applied over a colored ground. Usually red works best under gold, while silver leaf looks best over a black or ochre ground. We are here adding red colorant to the white shellac which will dry quickly and evenly.

6 Applying shellac. The area to be gilded is being given a coat of the red-colored shellac. Work quickly to avoid streaks or pile-ups.

7 Applying gold size. Here in the final stage of preparation we are coating the entire red area with transparent gold size. The frame is then set aside to dry for about 1 to 2 hours.

8 Testing size. It is extremely important that the size be in the right condition before applying the leaf. Size that is too wet will dissolve the leaf, while a too dry size will result in a weak gild, easily rubbed off. Test the size after about an hour by touching your knuckle to it. When it is just slightly tacky it is ready. Gilders refer to it as "whistling" tacky.

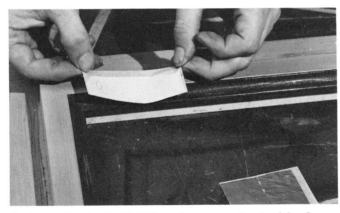

9 Applying leaf. Holding the paper-backed leaf as shown, we gently roll it against the sized area. These photos show one more advantage to using paper-backed leaf. We have cut the leaf into easy-to-handle strips with a razor blade. Cut the strips slightly wider than the surface to be gilded.

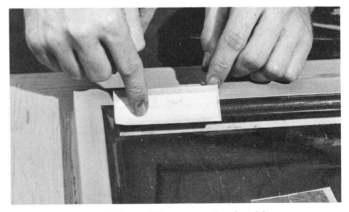

10 Pressing backing. We press the backing, very lightly, to make sure the leaf is completely covering the sized surface.

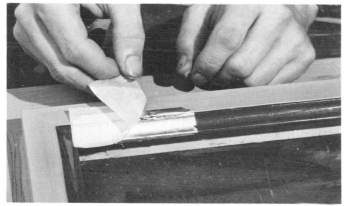

11 Removing backing. The gold leaf will adhere to the size while we gently peel off the paper backing. Repeat these steps around the entire frame, overlapping each application slightly.

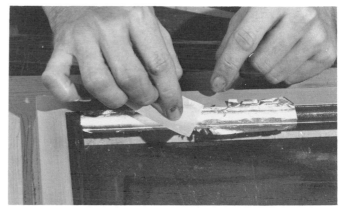

12 Leaf applied. The insert has been gilded and is ready to be burnished to clean up the ragged appearance.

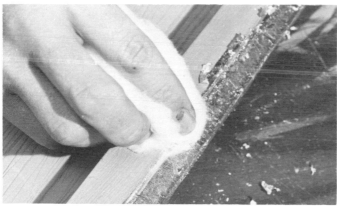

13 Burnishing. We burnish the gild with absorbent cotton. Rub lightly; this step is to clean up the edges and lightly buff the gold.

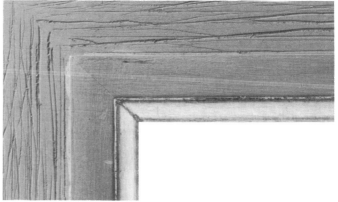

The completed gild

The Hard Way: Synthetic Leaf

1 Gilder's Tip. A gilder's tip is a flat, wide, soft-bristled brush used to transfer the leaf from its backing to the frame. The tip holds the leaf with a charge of static electricity which is created by brushing the tip lightly across your hair before touching it to the leaf. The surface of our frame has been prepared following the first eight steps for gold leaf, through "testing size." Here we are applying the synthetic gold leaf. The book of leaf is held as shown and the leaf scored through with the fingernail. After passing the brush lightly over the hair, the cut strip will stick to it and can be shifted to the surface of the frame. This is a tricky operation and will take some practice. Try to work in a room free from drafts or the leaf will act like the will-o'-the-wisp.

2 Sanding. We have gilded and burnished the frame and for this finish are sanding the leaf lightly. Note the effect created when some of the red ground is allowed to show through the gold. This is one variation; there are others. A light spatter of black also works well. Experimentation will show you more.

And the Easiest: Wax Gilding

Ordinarily gilding is an operation most beginning framers avoid because of its complexities and the skill needed to apply a good gild. The methods we have shown you thus far have, we hope, dispelled some of the mystery surrounding this phase of framing. If you still feel somewhat timid about using metal leaf, here is the simplest way to add gilding to your framing repertoire. This easy-to-follow procedure is perfectly satisfactory and lasting.

1 Applying patina. We start by preparing the frame with a coat of patina.

2 Mixing. Our gild is mixed by rubbing the wax into some of the bronzing powder which we have poured into the mixing tray.

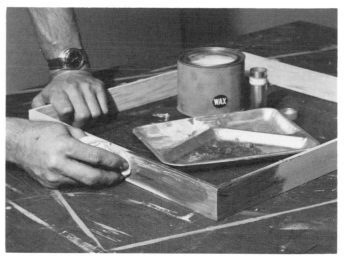

3 Applying gilt. Simply rubbing the wax gilt mixture over the thoroughly dry frame completes this gild.

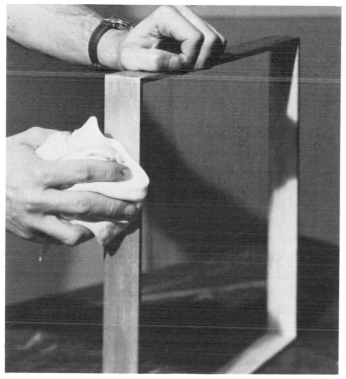

4 Buffing. The wax gilt is allowed to dry. We then buff the frame with a clean soft rag to bring out its rich, mellow sheen.

The finished frame

Archival Preparation

For most amateur framers the decisions involved are mainly aesthetic—concerned with the enhancement and presentation of personally prized works of art. There are other considerations, however.

As evidence comes to light regarding the effect of the environment on pictures, more and more research has gone into the preservation and protection of artwork. The air pollution that has eroded the statues of Venice presents the same dangers to the art you frame for your home. The acid in the Venetian air is also present, to some degree, in the air in your home. Most surely, it is present in wood and in the wood and paper products frequently used in framing.

This concern has resulted in a great deal of research to find methods and materials that will help defeat or at least slow down the destructive effects of the acid. The practice is called archival, museum, or conservation framing, because it is always used by museums to protect their valued works.

The diagrams show you how to use the materials available to construct a safety barrier for your art. The word to remember is *isolation:* the goal is to separate the art work from the frame. The materials used to isolate the art from its acid-rich environment must be acid-free themselves (mats and papers containing no sulphites and with a neutral pH).

Acid-Free Mats. Usually available from your art-supply store as "museum board" or acid-free ragboard, they should be used whenever the mount touches the art.

Museum Mounting. Your mat should be hinged with linen tape to an acid-free ragboard mounting board. Tear hinges of ricepaper and attach them to the art and backing board with wheat-starch paste. *All* materials should be acid-free.

Backing. Very often corrugated cardboard is used as backing. If you're interested in archival framing, *don't use it.* It is highly acidic and will eventually go right through the acid-free board and attack your drawing or painting. Use double-thick mounting board or chemically inert foam-core to create a strong physical and chemical barrier.

Sealing. It's important to get, as nearly as you can, an airtight seal between frame and glass. The paper dust-seal must be securely glued to help keep the vicious sulphur dioxide at bay.

This is a very brief look at the materials and methods used for archival framing. If you're interested in delving further into this scientific approach to preserving your artwork, we can recommend, among other books available at your library, *Curatorial Care of Works of Art on Paper* by Anne F. Clapp, published by the Intermuseum Conservation Association.

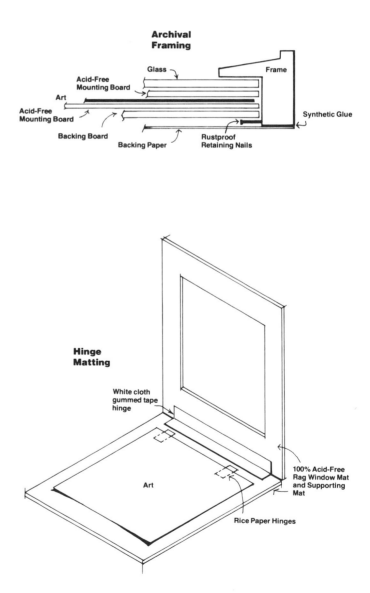

Mounting Prints and Reproductions

Prints, drawings, photographs, maps, and other things you may want to keep are often printed on paper that doesn't have sufficient body to bear up under usage and time. They can be made more substantial and permanent by mounting them on a rigid support.

A Quick Method: Wet Mounting

The mounting procedure we show you here is the best all-around method we have found. It works well for anything from a photograph to a canvas, and you can mount your picture on almost any surface. Because we will eventually frame our demonstration print in a small frame, we chose acid-free museum board as a firm but lightweight backing. Old canvases of either sentimental or actual value can also be preserved and protected by mounting them in this way, and with a little care even small tears can be almost completely hidden.

For the adhesive we recommend a synthetic glue like Jade #403 (see Sources). It is clean and easy to handle, and is water soluble, making clean-up of brushes and working areas quick and simple. It stores well and, most important, has wonderful holding power.

Mounting prints is not difficult if you will observe two simple rules: first, have plenty of newspapers handy; second, *keep your hands and tools clean.*

Tools. Yardstick, mat knife, roller or rag, C clamps.

Materials. Acid-free museum board, glue, two pieces ³/₄ inch (1.9 cm) plywood.

1 Measuring. Measure your print carefully and check it for squareness, then with a yardstick mark off its size on your museum board; or as we have done, since our print was square, simply lay the print on the board and trace around it.

2 Cutting. We hold the mat knife vertical against the straight edge and cut the board to size.

3 Gluing. We quickly brush glue on one side of the board, covering the entire surface.

4 Gluing. We even out the glue by brushing it over lightly in one direction. The trick in gluing is not to get too much or too little glue on the surface so that it will hold well but not squeeze out when rolled.

5 Positioning. If your print is very large, wet it first to avoid bubbles, then quickly place the print on the glued surface. Here care must be taken to get your print in the right position, because once down it can be moved very little.

6 Rolling. Starting in the middle, with firm pressure, we work toward the outer edges, rolling out bubbles and excess glue—with practice there won't be much. Be sure not to get glue on the roller; you can cover your print with a light sheet of paper to prevent this.

7 Pressing. If you mount only an occasional print it is possible to use a clean soft rag in place of the roller. However, greater care must be taken not to damage the surface.

8 Clamping. We place a clean sheet of paper over our print and clamp it between two pieces of ³/₄ inch (1.9 cm) plywood for an hour. (One board and a stack of books for a weight would work as well.) If any bubbles occur, smooth them out with your finger and place under pressure again.

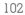

Dry Mounting

If you're looking for a way to mount photographs, drawings, reproductions, prints, and diplomas permanently and flat, your best bet is dry mounting. This procedure uses heat and an adhesive sheet to fuse your photo or print to a stiff backing, creating a "sandwich" of absolute flatness and permanence.

If you are going to be mounting a great many prints you may want to invest in the dry-mounting press shown here. However, they are pretty expensive, so if you only have an occasional print to mount we also show you a "home-grown" way to use an ordinary iron to accomplish the same results.

The Pro's Way

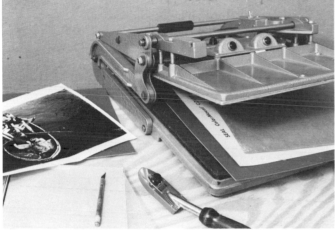

Tools and materials. We're going to mount a photograph to an acid-free matboard. A tacking iron, X-acto knife, dry-mounting press, dry-mounting tissue, some brown paper, and we're ready to begin. Warm up the press *now* according to manufacturer's instructions.

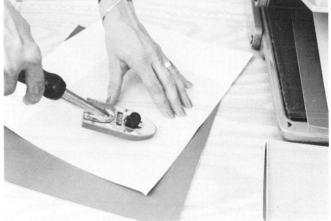

1 Tacking. Place your print face-down on a sheet of board and cover the back of the photo with mounting tissue. Line up at least two edges of the tissue with two print edges (to save trimming later on). With a warm tacking iron tack through the tissue in a spot along one edge.

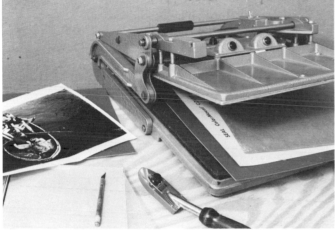

2 Tacking. Butt additional sheets to cover the back of the photo completely. Match the sheets *carefully*. Don't leave any gaps (they'll bubble) or create any overlaps (they'll make ridges). Tack through along one edge.

3 Trimming. Trim tissue to exact size.

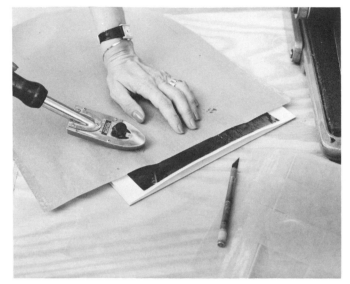

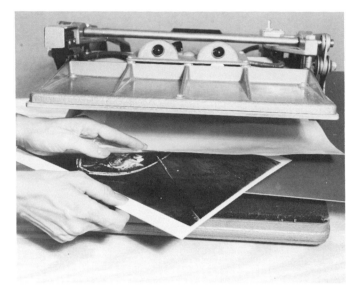

4 Tacking. Turn your photo and its tissue face-up on the same matboard. Position carefully. Cover the photo with a piece of brown Kraft paper and tack one edge of the photo through the protective brown paper.

5 Assemble materials. Assemble the following, from bottom to top on the sponge bed of the press: (1) an extra piece of matboard, (2) the backing/tissue/print sandwich, (3) a protective release paper (supplied with mounting tissue) or brown Kraft paper cover.

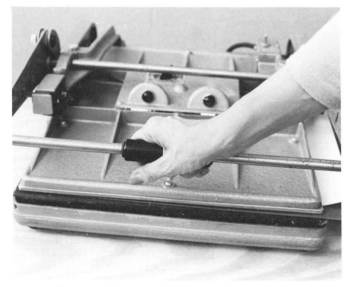

6 Bonding. Lock press closed for 30 to 45 seconds for regular mountboard—longer if necessary for larger or thicker sizes.

7 Cool under weight. Holding them together, re-move all materials from press and place under weight to cool. Do not bend or flex work in handling.

The Home Method

Use an iron. *All is the same, except you can use a regular household iron. Note: Do not use steam!*

1 Tacking. With your iron set on "linen" follow the tacking procedure explained before.

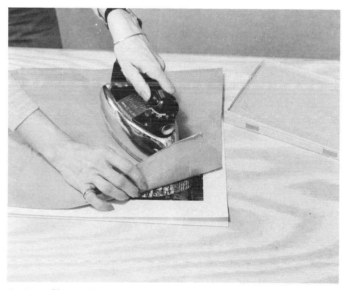

2 Bonding. With your print sandwich in position and a protective paper over its face, press down heavily with the iron. Work from the center out, holding the iron in position for a few seconds—long enough to create a bond.

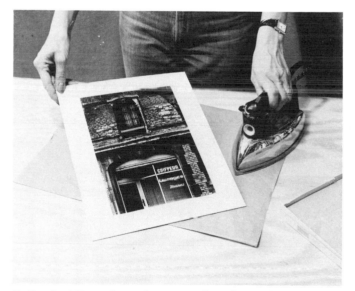

3 Cool. Allow the print to cool under weights as before.

Cutting Mats

Watercolors and drawings are shown at their best when a mat is used. Matboard is available at any art-supply store and comes in a variety of colors. It usually has a pebble finish and each side is a different color. The most useful color combination is white on one side and gray on the other. Watercolors are generally matted with white, but in many cases a cream, gray, or tinted mat will heighten the color or the overall effect. The matboard you buy is usually about 1/8 inch (.3 cm) thick and can be used as soon as it is cut. Before you purchase your matboard or the board your art will be mounted on, please read the section on archival preparation on page 100. The life you save may be your favorite picture.

A mat should be wide enough to separate the picture from busy surroundings without being so wide that it makes the picture appear smaller. While requirements may vary for each picture, we have found a 3 × 4 inch or 2½ × 3 inch (7.6 × 10.2 or 6.4 × 7.6 cm) mat will work well with most paintings. (Generally a mat is the same width at the top and sides and slightly wider at the bottom; thus a 3 × 4 inch mat is 3 inches wide at the top and sides and 4 inches wide at the bottom.)

Practice cutting small mats out of scraps of board, then follow the procedure we show you, and you will soon be cutting your own professional looking mats.

Tools and Materials. The mat we are going to cut is made from a piece of acid-free museum board. A straightedge, yardstick, mat knife, pencil, compass, linen tape, our picture, and we are ready to begin.

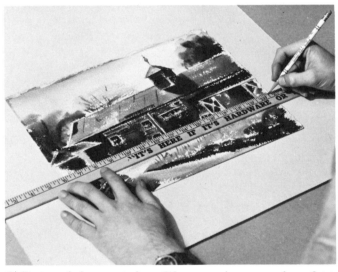

1 Determining mat size. We are going to make a 3 × 4 inch (7.6 × 10.2 cm) mat so we are adding 6 inches (15.2 cm) to the width of our painting to determine the overall width of our mat. For the height we add 7 inches (17.8 cm).

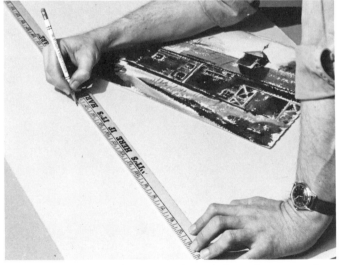

2 Measuring. With our matboard face-down on the flat, clean surface of the table, we mark the overall dimensions. Do all of your measuring and marking on the back of your board to keep the face clean.

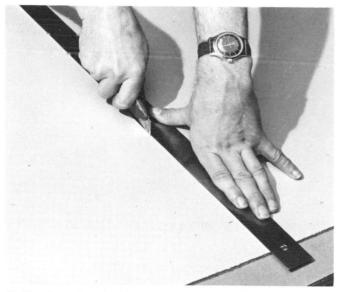

3 Cutting. We hold our straightedge firmly on the marks we have measured and with the mat knife held at a right angle to the matboard we draw it along the edge. A sharp knife will make this cut in one pass with the right pressure. Now cut your mounting board in the same manner to the outside dimensions of your matboard.

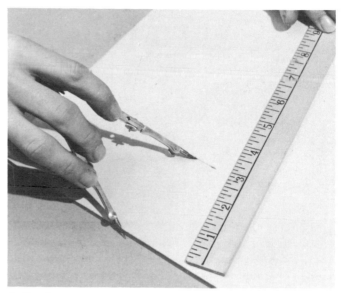

4 Setting compass. After setting the compass at 3 inches (7.6 cm) we hold the metal point against the edge of the mat and draw the compass along the top and sides.

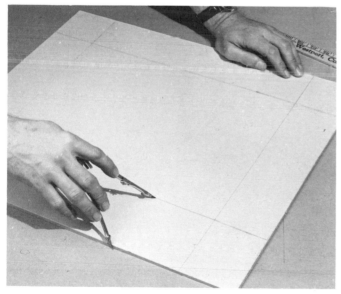

5 Ruling. The bottom line is drawn in the same way after we have reset the compass to 4 inches (10.2 cm). Notice that all the lines are carried out to the edges to allow us to check our dimensions before we begin cutting.

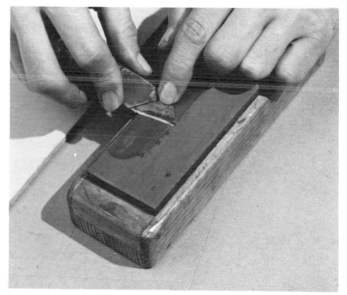

6 Sharpening knife. To avoid a ragged edge next to the picture it is important to cut the inside edges in one stroke. We find a whetstone invaluable for sharpening our blade between each cut. Or, since blades are quite inexpensive, always keep a fresh blade in your knife.

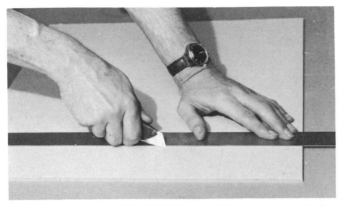

7 Cutting. Two nails hold the straightedge steady for our cut. We push the point of the knife, at an angle, into the matboard about ¹/₈ inch (.3 cm) beyond the corner. This overcutting ensures sharp corners, and because this mat is beveled, the overcut will be only about ¹/₁₆ inch (.2 cm) on the face of the mat and will not be noticeable.

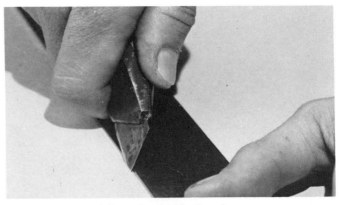

8 Cutting. Holding the knife firmly at a constant angle, we make the cut in one smooth stroke.

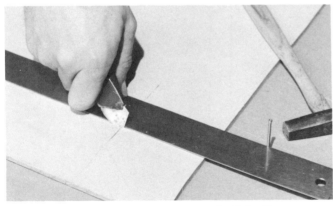

9 Cutting. When we get to the end of the line we cut ¹/₈ inch (.3 cm) beyond the corner. The remaining three sides are cut in the same way. Remember to make all these inside cuts in one stroke to avoid a ragged edge. If you do make a slightly rough cut it can be smoothed with a light sanding, using very fine sandpaper over a sandblock.

10 Hinging. Laying the mat face-down on our clean surface, head-to-head with the face-up backing board, and using a length of white linen tape, we hinge our mat to the backing along the top edge of both. (The tape we're using here is not 100% acid free. If this is a concern to you, please read the section on archival mounting on page 100).

11 Positioning. Next we place our picture face-up on the backing, under the mat, adjusting its position until we get it framed just right. We then lift the mat and lightly mark the corner locations on the backing so we can easily reposition the painting later.

12 Taping. We prepare to hinge the picture to the backing with two small pieces of linen tape. About 1/8 inch (.3 cm) of the tape is attached to the *back* of the painting at the top edge, about 2 inches (5 cm) in from the right and left.

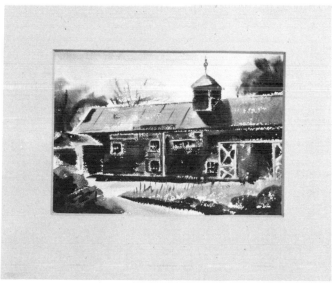

13 Taping. Repositioning our painting within the corner marks on the backing, we stick a second piece of linen tape *face-down* over the protruding tapes and onto the backing, thus hinging our picture to the backing. Note that the tape is not stuck onto the front of the painting but rather on the back where it can do no harm—and only then on the very edge. This type of hinging allows the picture to expand or contract under the mat without buckling.

The finished picture. Our finished picture, matted and ready to be framed.

The Incredible Mat Machine

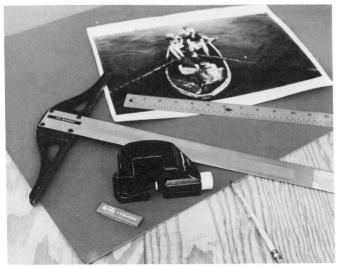

If you have a lot of mats to cut, here's a tool that can make the process easy and accurate. There are several on the market to choose from; examine them at your art-supply store. They all work in the same manner. Pick one with adjustable blade angles so you can cut mat windows with beveled edges. A mat cutter, ruler, T-square, matboard, and your print, and you're ready to go.

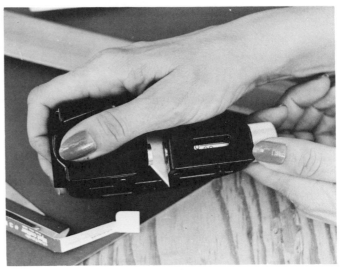

1 Setting the blade. Insert a blade in the mat cutter with the sharp edge facing the front of the cutter. Rotate the blade to a 30°, 45°, 60°, or 90° angle. Slide it back down until the blade slightly penetrates the protective cardboard pad.

2 Close-up. In this close-up you can see how the blade is set to cut through the mat, and just cuts into but not through a cardboard pad which protects the surface below the mat.

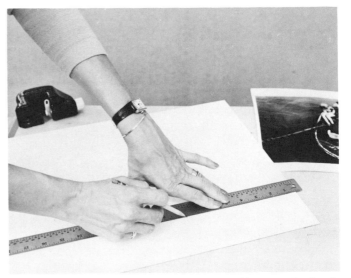

3 Measuring. Lay out your mat, working on the back with accurate, lightly drawn guide lines (use a T-square).

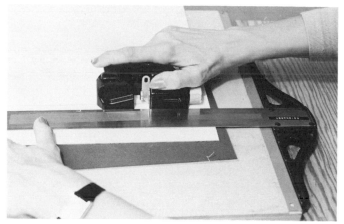

4 Cutting. Square up the mat with the T-square. Gently force the blade point through the mat where the guide lines meet.

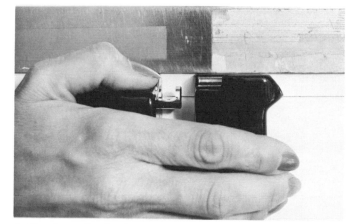

5 Cutting. Push the mat cutter forward, applying slight downward pressure while firmly holding the T-square in position to use its straight edge as a guide.

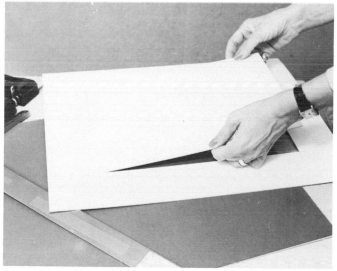

6 Cutting. Repeat the cutting procedure on the remaining sides of the window. *Note:* Approach corners carefully to avoid overcutting. Lift out the cut-out center of the mat.

7 Finished mat. Here's our finished mat, ready to hinge over our mounted print and be framed.

Covering Mats and Inserts

Inserts and mats are really frames within frames. As such, they may be finished using any of the methods we have shown you for finishing the frames themselves. With imaginative treatment of the insert, picture and frame can be made even more impressive. Experiment with a variety of finishes; remember, however, that because they are next to the picture, restraint is needed to make sure the insert or mat complements the frame without overpowering the picture.

In this respect a fabric covering is very often the perfect solution. Raw linen, monkscloth, and sometimes burlap are used because of their neutral tonality, but for certain pictures other fabrics may also be used to achieve very fine effects.

There are two generally accepted ways to cover inserts. In the first, the strips of molding are covered with fabric before joining. This results in neat miters, but the cloth on the molding stands a good chance of being damaged or soiled during assembly. In the second method, which we prefer, the insert is completely assembled before being covered. This avoids excess handling of the molding, and with a little practice the corners can be mitered perfectly with your mat knife or razor blade.

A mat may be covered in the same way. However, because of its width, it usually looks better when it is covered using a single piece of fabric without mitering the corners. On the next several pages we show you the methods we have found best for covering both mats and inserts.

Tools. Scissors, mat knife, brush.

Materials. Raw linen, glue, insert, mat.

Covering Inserts

1 Cutting. We start by cutting four strips of linen. The strips should be about 2 inches (5.1 cm) longer than the sides to be covered, and wide enough to cover both the face and the entire rabbet.

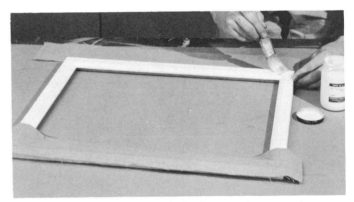

2 Gluing. Working carefully from miter to miter we brush an even coat of glue over the face of one side of the insert. The strip of linen is then laid in the position shown. Notice that it overlaps the corners and edges. The four sides are covered in the same manner. Press the cloth into the glue *lightly*. Too much pressure will cause the glue to come through the cloth and make an unsightly blemish which cannot be cleaned up.

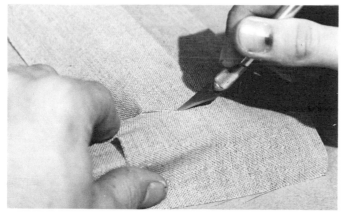

3 Cutting. With our knife sharpened, we start at the inside corner of each miter and cut through *both* thicknesses of cloth where they overlap. Cutting through both pieces at once ensures a perfect match.

4 Finishing miter. Lifting the top piece of linen we remove the excess bottom piece and press the top piece back into position in the partially dried glue. Repeat these steps in each corner.

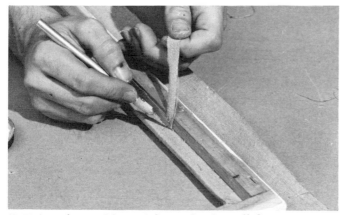

5 Trimming rabbet. After mitering all four corners we spread glue along the entire rabbet and fold the fabric around the inside edge. The excess cloth is then trimmed off with our knife.

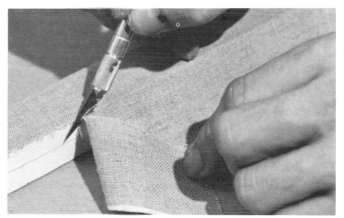

6 Trimming edge. The frame will hold the insert, so there is no need to cover the outside edge. Here the excess linen is being trimmed flush with the top of the insert.

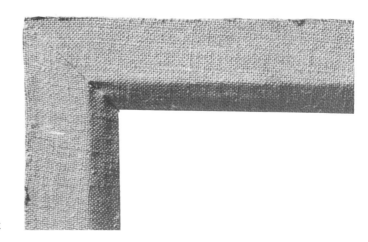

The covered insert

Covering Mats

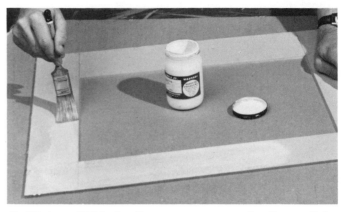

1 Cutting. We spread the linen out on the flat, clean surface of our table and cut a piece about 1 inch (2.5 cm) larger than our mat all around.

2 Gluing. With the linen cut, we coat the front of the mat with a thin, even coat of glue.

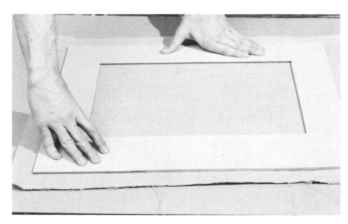

3 Positioning mat. The linen is again spread flat and the mat placed glue side down, centered and pressed *lightly* in place.

4 Smoothing. Turning the mat and linen face up, we go over the entire face smoothing the linen in place. We work quickly and very lightly to avoid unsightly glue spots. Here again, too much pressure will cause the glue to seep through the cloth.

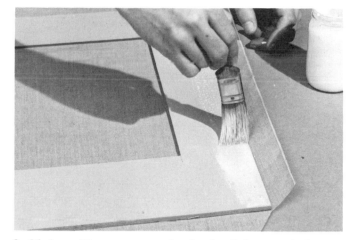

5 Cutting. To facilitate gluing the outside edge, a small piece of material is cut away from each outside corner. The cut is made at a 45° angle to the corner so that there is no overlapping when the cloth is folded over the edge.

6 Gluing. Here you see the back of the mat being given a coat of glue. Notice the angle of the cut we made in the previous step. Coat the entire outside edge with glue.

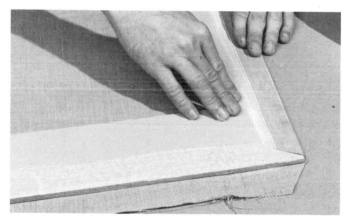

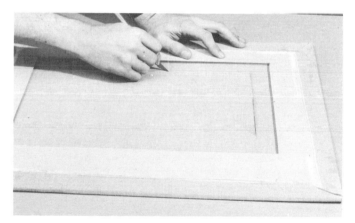

7 Smoothing. We now fold the outside edges of our material over the back of the mat and press them *firmly* in place.

8 Cutting. With our mat still face-down and the outside edges glued, we cut out the "window." We leave about 1 inch (2.5 cm) extra to fold over the back of the mat.

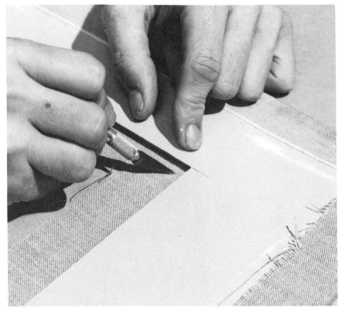

9 Cutting. Starting about ⅛ inch (.3 cm) in from the corner to allow for the thickness of the matboard, we make a single miter cut to the inside edge of the material.

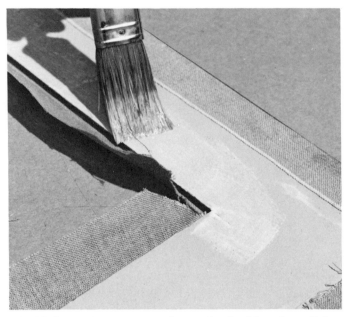

10 Gluing. Now we coat the entire inside edge of the mat with glue.

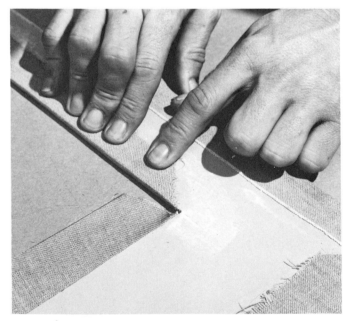

11 Smoothing. The inside material is folded over and we are pulling it tightly against the edge of the mat. The extra ⅛ inch (.3 cm) we allowed will pull tight against the corner, resulting in a slightly rounded, neat frame for our picture. If we had cut right up to the corner, a gap would appear at this stage which would detract from the quality of our mat.

The covered mat

116

How to Cut Glass and Acrylic

Except for oil and acrylic paintings, most other types of art are framed under glass. Watercolors, pastels, posters, prints, reproductions, etchings diplomas, certificates and the like need the protection of glass or acrylic.

Acrylic is much lighter in weight, which can be a real advantage in framing a large picture. However, it scratches easily, tends to collect more dust from static electricity than glass, and usually costs more. Both glass and acrylic are available in a nonglare surface. We personally don't care for nonglare since it somewhat reduces the visibility of the picture. But if your favorite watercolor *must* hang in a spot that picks up a lot of reflection, it might be just the answer you're looking for. Ultraviolet-filtering acrylic is also available for very valuable or extremely fragile artwork. As you might expect, both the nonglare and filtering surfaces are more expensive than regular glass or acrylic.

You can buy acrylic from companies that sell plastic-cutting tool and save yourself a lot of extra frame shops. It is sold under several trade names like Lucite or Plexiglas and comes in large sheets that you can cut to size yourself, or most places will cut it for you for a fee. Acrylic is easier to cut than glass: you can purchase a large sheet and a plastic cutting tool and save yourself a lot of extra trips back and forth. Cutting acrylic is much like cutting a mat—a few practice cuts and you'll wonder why you ever paid anyone to do it for you. Use the cutting tool (a knife with a hooked point) against a straight edge, drawing it toward you as if you were cutting a mat. Make several passes until you have cut nearly through, then lay the scored line over the edge of a table and snap it off. The rough edge can be filed, then sanded smooth with successively finer grits. Because it scratches easily, acrylic is sold with a protective paper covering on both sides. Do all your cutting with this covering intact. The covering also keeps the acrylic clean until you are ready to place it together with your picture into the frame. Acrylic cleans easily with a plastic cleaner or dishwashing detergent, water, and a soft lint-free cloth. *Do not use* any of the commercial glass cleaners: they destroy acrylic. Little bits of dust can best be removed with a photographer's wipe or static-free brush from a photo store.

There is something about handling and cutting glass that frightens most of us. However, if you will get a piece of glass to practice on and follow these four basic rules, you will be an expert in about fifteen minutes.
1. Always work on a perfectly flat surface. Professionals usually have their bench covered with a piece of carpet, but a thick bed of several layers of newspapers will level most table tops.
2. Clean your glass. If it is new it is probably clean, but if you are using old glass be sure to clean it thoroughly.
3. Always dip your cutter in kerosene or turpentine before each stroke. This aids the cutting wheel to make a clean cut.
4. Never, *but never*, go over a cut. Make it right the first time.
Now relax and have some fun cutting freehand shapes in your practice piece like the ones in our illustration. Then try some cuts against a straightedge. You will get the feel of the cutter and an idea of how much pressure it takes to make the "scratching" sound of an effective cut. You will find out how fast or slowly to draw the cutter and exactly how much pressure to apply at the edge of the glass as you finish your stroke. To break the glass you can follow the steps illustrated here, or pull the glass a couple of inches over the edge of the table so you can hold it on either side of the cut, thumbs on top, fingers beneath. A little up-pressure on the fingers and down-pressure of the thumbs, and snap! Surprise! The glass parts cleanly along your cut line.

A few extra points to remember: (1) A dull cutter requires too much pressure and will cause

First, practice on free-form shapes.

skips in your cut line. (2) Measure carefully. Trying to cut 1/8 inch off a piece of glass that has been cut a whisker too big is really difficult. It can be done, and we've done it, by gently nibbling the newly cut edge with pliers. But it's not fun, and usually results in a ragged edge. And finally, (3) even though you've now discovered that cutting glass can be fun, especially those freehand shapes, do remember that you are handling *glass,* it can be *dangerous.* Don't be afraid of it, but do handle it with care.

You can clean your glass with any clear glass cleaner or make your own as the pros do. If you choose to use a commercial cleaner, it's better to dilute it with six to ten parts of water. If used undiluted, most cleaners leave a residue on the surface that tends to dull your picture ever so slightly. To make your own cleaner, which is much cheaper, use eight cups water and one cup alcohol. Add to this two tablespoons of rottenstone (from your hardware store) and one tablespoon of dishwashing detergent. Ammonia is sometimes substituted for alcohol but the strong odor is unpleasant. The alcohol or ammonia will cut any oil or grease on the surface while the rottenstone polishes and brightens your glass. The tablespoon of detergent acts as an antistatic agent.

Tools and materials. Straightedge, yardstick, pencil, glass cutter, glass, turpentine, rag.

Cutting Glass

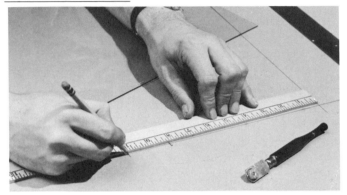

1 Layout. We have leveled our table top and have drawn a right angle on it. Along one side we mark the two dimensions of our picture, in this case 8 and 11 inches (20.3 and 27.9 cm).

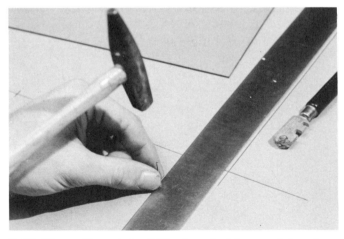

2 Nailing. Since it is difficult to hold a straightedge firmly on glass, we position ours for the cut and drive in one brad at either end to hold it steady.

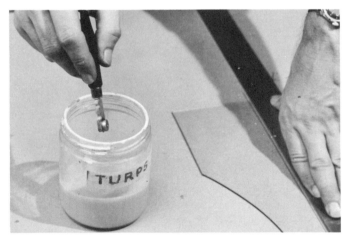

3 Dipping. We bring one end of the glass up to the 11 inch mark and under the straightedge. Just before making the cut we dip our cutter in turps.

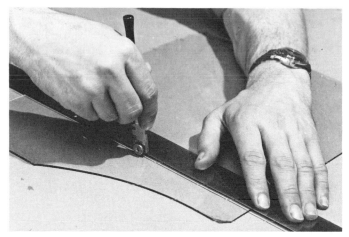

4 Cutting. Holding the straightedge against the brads and the cutter vertical against the straightedge, we draw the cutter with firm pressure across the glass. Your pressure is right when a clear "scratch" sound is heard.

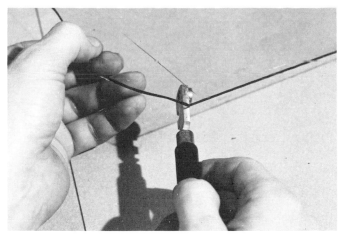

5 Tapping. With the cutter we give a sharp tap on the underside of the glass directly under the cut. This starts the break. The Red Devil cutter has a heavy little ball at the end of the handle which is specifically designed for this tapping action.

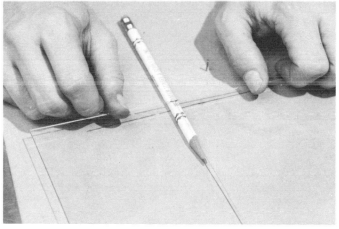

6 Positioning. We place the spot where the break has started over a pencil, with a little pressure applied to either side.

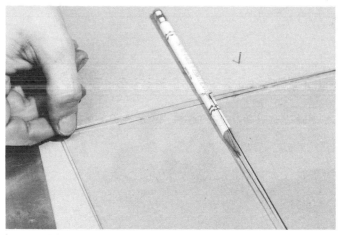

7 Breaking. Snap! Our cut has been cleanly made and the glass parts down the full length. We move the glass under the straightedge to the 8 inch mark and make the second cut the same way.

Antique Frames

Attics, cellars, secondhand stores, and junk shops are wonderful hunting grounds for old frames. These frames are seldom usable as they are found, and restoring (that is, returning the frame to its original condition) is a complex operation. Even then, the ornateness of most of the carving is usually too much for any painting to overcome. However, they are generally well constructed and the basic design of their moldings, with a little modification, can be made suitable for even the most contemporary paintings.

Our purpose here is to show you how to use these "junk" frames as a starting point from which you can create distinctive one-of-a-kind frames combining the richness of the past with the tastes of today.

The main thing to keep in mind when you are finishing old frames is that there are no rules or set procedures. Each frame will be a different problem with its own solutions dictated by the design of the frame and the picture you are framing. The trick is to take advantage of the unique good features of your frame while getting rid of the distracting overdecoration so typical, for instance, of Victorian picture frames.

The raw materials from one attic.

Preparing the Antique Frame

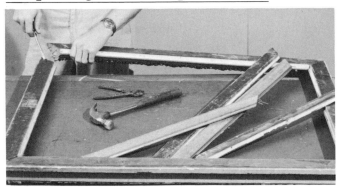

1 Disassembling. Sometimes when finishing an old frame it is necessary to rebuild it. Here the insert has been knocked down and we are taking the frame itself apart.

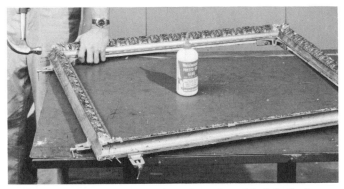

2 Reassembling. After cleaning the old dried glue from the miters, we reconstruct the frame. Note the framing clamps used at each corner to ensure squareness and maximum strength.

Antique Frame No. 1

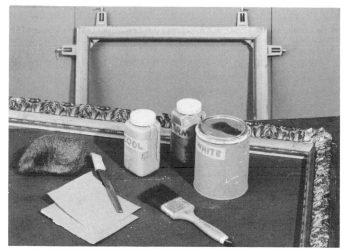

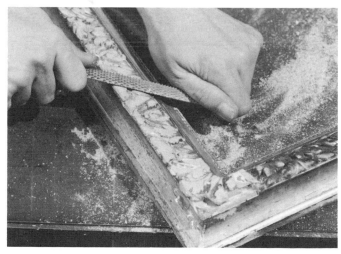

1 Ready to begin. Our patinas, white vinyl gesso, brush, steel wool, sandpaper, and a wood rasp are the tools and materials we need to complete the job. As a safety measure, we have wrapped the handle of the rasp with tape.

2 Rasping. It takes determination seemingly to destroy the "beautiful" carving, but the first step is to rasp the entire surface of the frame. Work vigorously until all of the decoration has been taken down and softened.

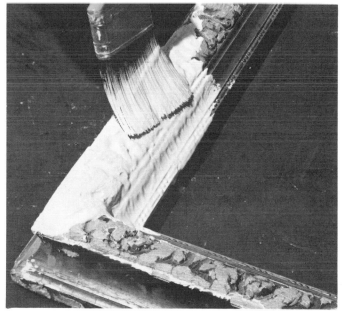

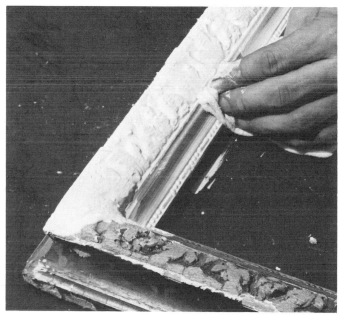

3 Applying gesso. Here we are giving the rasped frame a coat of thick, undiluted vinyl paint. Work the paint well into the valleys; as you can see, this step is a further softening of the carving. We are getting somewhere—the carving is now a texture rather than clearly defined flowers and bows.

4 Wiping edge. The inner edge of this molding has a good simple curve, so before the vinyl is completely dry we wipe it off partially to allow some of the gold leaf to show through.

5 Toning. After the vinyl gesso has dried thoroughly we tone the frame with successive wipes of our warm and cool patinas. From this point on, the frame is finished as we did in the demonstration on page 93.

6 Sanding. Our frame is finished, so we begin to sand the insert. We found a layer of silver leaf under the gold, which we will take advantage of by sanding only enough to expose parts of the silver and still keep parts of the gold. Note how the two colors create an interesting texture.

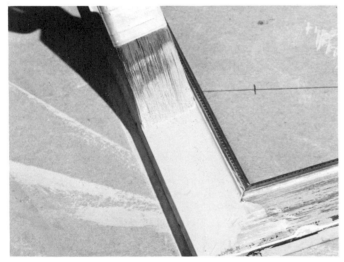

7 Toning insert. A coat of patina is now applied to the entire sanded surface of the insert.

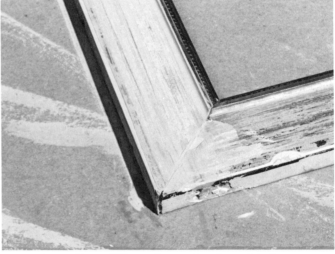

8 Steel wooling. When the patina has dried we go over the surface lightly with our steel wool. This patina, gold, and silver finish will go nicely with the frame and picture.

▶**The finished frame.** This is a good example of taking what you may find on the frame and modifying it only enough to make it work well.

Antique Frame No. 2

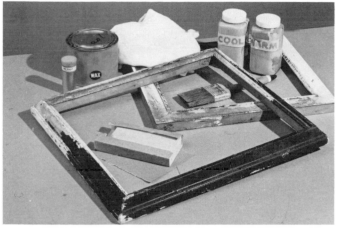

1 Tools and materials. Here we rebuild a small frame and insert—much less elaborate in style than the previous one, but with useful qualities. Our patinas, brush, bronzing powder, wax, sandpaper, and a rag.

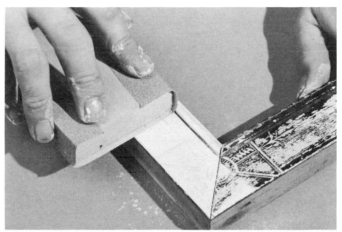

2 Sanding. Under the rather frightening black enamel we find an excellently applied gesso ground. We sand the entire insert enough to get rid of the black and soften the "cute" carving.

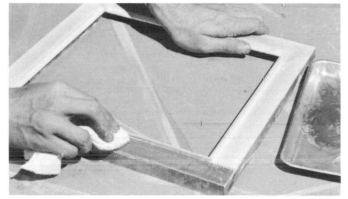

3 Wax gilding. The white gesso we have uncovered provides an excellent ground for a wax gild. This simple step completes the insert.

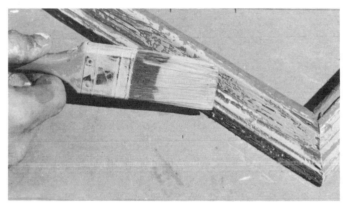

4 Applying patina. We raked the frame to incorporate the nicks and scars into a texture, gave it a coat of cool patina, and are now dry-brushing the surface with a lighter-value warm patina. This in turn will be lightly sanded and waxed to give us the effect you see in the completed frame.

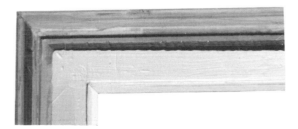

The completed frame

The Final Steps

Here are the final steps to getting your pictures where you want them—on the wall. The job is a simple one but of great importance in presenting your pictures at their best. A good job of assembly will actually help strengthen and reinforce your frames, while a poorly fitted picture will not stand the ravages of dust and time for long.

When you reach this final stage—putting picture, mat, frame, and glass (if used) together—it's a good idea to have a table-top-size piece of carpet that can be used as an assembly surface. The carpet won't scratch your newly finished frame or break the glass.

The most important thing about hanging your pictures is to make sure the hook is strong enough to hold its weight. If your wall is solid—wood, paneling, studding—the simple brad-and-hook combination can be hammered in. On hollow- or dry-wall construction you should use any of the expansion-type anchors. Your hardware store can show you what is available and tell you how to install them.

There are also stick-on types of hangers. Be careful: make sure they're rated to carry the weight of your picture and follow the mounting directions exactly.

Another interesting way to hang your pictures is from a picture molding fastened to the wall up near the ceiling—an old idea, but worth thinking about.

Cleanliness, careful workmanship, and these easy-to-follow steps will result in framed pictures whose fine appearance will last many years.

Tools. Yardstick, pliers, scissors, ice pick, X-acto knife or razor blade, rags.

Materials. Our picture, glass, and frame. Wrapping paper, screw eyes, picture wire, 1 inch (2.5 cm) brads, a piece of matboard backing the same size as the matted picture.

1 Backing picture. We have cleaned the glass thoroughly, placed it and the picture into the frame, and are here installing the backing board. *Note:* Be sure the rabbet is free of any unevenness. When glass is used, a small drop of excess glue or paint will prevent even contact and eventually cause the glass to crack.

2 Nailing. We use the pliers to push the brads through the backing board into the frame. This method of inserting brads avoids hammering the frame and should be used whenever possible. Note the masking tape wrapped around the pliers to protect the frame. (If you're planning to do a lot of framing there is a special tool called a fitting tool or brad pusher you might like to invest in.) Place the brads as flat as possible with just enough angle to go through the backing board. After placing one brad in each side turn the picture and check its position; if it's all right, place brads about 3 inches (7.6 cm) apart all around the frame.

3 Wetting paper. We have cut the brown wrapping paper about 1 inch (2.5 cm) larger than our frame and are here wetting it with a rag and water. This slight dampening will cause the paper to stretch so that when it drys on the frame it will shrink to a smooth, neat, dustproof cover.

4 Gluing. We now spread an even coat of glue around the back edge of the frame.

5 Positioning paper. During the gluing step our paper has stretched, so we now place it in position and smooth it out. It is not necessary to get the paper drum tight—it will tighten up as it dries.

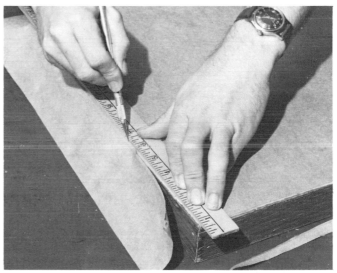

6 Trimming. Using our yardstick as a straightedge, we are trimming off the excess paper. You can see how well the paper tightened up when it dried.

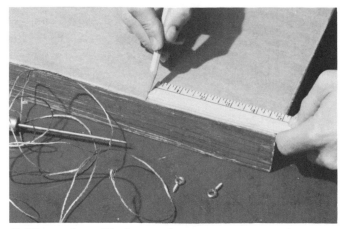

7 Measuring. To locate the screw eyes, we place a mark about one-third of the way down from the top of the frame.

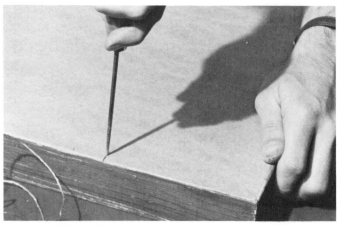

8 Punching. To make it easier to start the screw eyes we use an ice pick as an awl to punch a hole at each mark.

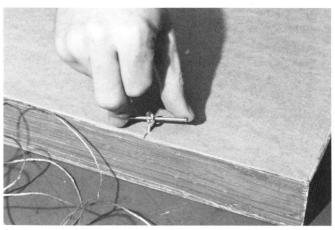

9 Installing eyes. A brad placed through the screw eye makes it easier to turn it in as far as it will go.

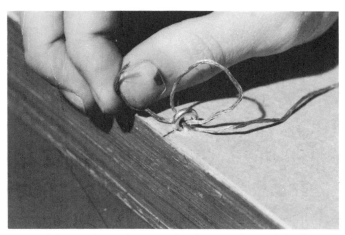

10 Wiring. Our picture wire is cut about 8 inches (20.3 cm) longer than the frame and is looped *twice* through each screw eye. The double looping strengthens the wire at the point of greatest strain.

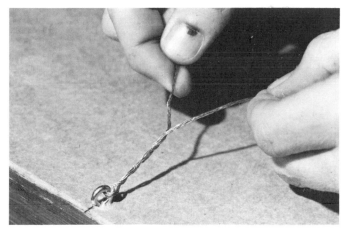

11 Wiring. We then twist the remaining wire back on itself about 3 inches (7.6 cm).

12 Ready to hang. The little bit of slack left in the wire helps the picture center itself on the hanger. Too much slack, however, will show above the frame and should be avoided, while a too tight wire will cause the picture to slide on the hanger and obstinately refuse to hang straight.

Preparing a Large Picture

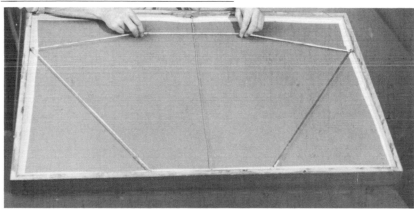

In this case we've taped the backing paper to the inside of the deep frame so that we can support the heavy picture from four points. The wire is fastened to the two bottom screw eyes and allowed to pass freely through the eyes in the sides. When the picture hangs, the pressure exerted helps pull the frame together. The single wire running through the center prevents the top and bottom from springing apart during handling. You may find it better to hang large pictures from two hooks to help carry the weight and assure a level picture. With the screw eyes on the inside of the frame, the frame will rest tightly against the wall instead of angling away from it.

EXAMPLES

On this and the following pages we show a variety of picture frames. Not all of them are taken from the demonstrations in this book, but all are based on the principles we have discussed.

We present these examples to show you that it is not always mandatory to "follow the rules"; rather it is more important to let each picture dictate its own needs. Notice particularly the variety of textures, materials, and molding silhouettes and how each frame carries out the feeling expressed in the painting it surrounds.

The key word is still neutrality. A frame should complement the painting without being gaudy or show-offish.

Alfred Chadbourn—Lobster Buoys—Collection of the artist

▲ *This painting, having an extremely strong pattern, would look well in almost any frame that echoed its angular character. Notice, however, that although strong and geometric in character, the molding does not compete with the picture because it is finished with a simple light-over-dark patina and a minimum of texture.*

▶ *A coat of gray patina and a raw umber glaze are all that is needed to give the textures on this handsome antique frame a wonderfully mellowed character. Notice how the delicate detailing of the frame beautifully complements the strong, direct, and spontaneous feeling of the picture.*

Charles Reid—Life Class—Collection of the artist

Dong Kingman, Guiding Faculty, Famous Artists School

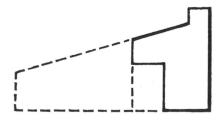

A single strip of drip cap ripped in half provides enough molding for this frame and the one on page 135. The lower half of the molding, rabbeted as shown, sets off this black-and-white reproduction of a Dong Kingman watercolor. The linen-covered mat is surrounded by a frame which is finished in flat black and has a wax gild on the sloping face. Notice how the linear quality of the frame handsomely complements the strong pattern and design in the picture.

Erno Czako—Landscape—Collection of Mr. and Mrs. Hal Rogers

To keep this very active painting contained, the thin top edge of the molding has been treated with pure white. The 1 × 4 backing has been raked and patinized to provide a harmonious transition from the wall to the picture. The whole effect is further enhanced by the frame's reverse design, in keeping with the tapestrylike character of the painting.

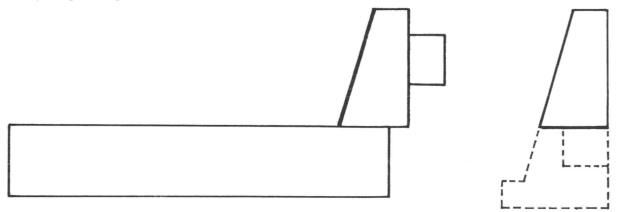

◄ *The powerful design of this abstract painting is beautifully enhanced by this striking frame. The wider inner edge of the molding is wax gilded with a cool coin gold while the thin outer edge has been gold leafed and sanded. This is the finish we demonstrated on page 98. The gold tones complement the rich reds in the picture and a soft velvety separation between the two temperatures of gold is created by painting the deep channel black.*

► *Here is a portrait which is quite different in feeling from the soft, muted study on page 131. The strong structural design of the figure and its environment requires a frame with a distinctly linear character.*

The finish is an easy one to achieve. The entire frame is coated with a light, warm patina; then the raked surface of the 1 × 4 is wiped with a darker tone to create the contrast which emphasizes the angular quality in both the frame and the composition. A thin, soft gold insert brings out the best in the warm reds and browns and adds richness.

Ed Reinhardt—Elsie—Collection of Miss Elsie Lengyel

Even though this picture is full of movement, a simple strip frame is all that is needed to present it at its best. Any more ornamentation would compete with the activity within the painting and rob it of some of its vigor.

The frame is simply finished with a wax gild and the depth of the 1¾ inch (4.5 cm) lattice strip gives the picture a pleasant feeling of volume when it is hanging on the wall.

This portrait by Ben Stahl calls for a frame which echoes the geometric treatment in the painting. Our first drip cap frame works excellently when we add a natural linen insert. The insert provides a good transition between the texture of the painting and the frame and also softens the whole effect.

To accentuate the delicacy of tone and line in this study we found the antique frame we used in the demonstration on page 123 a good solution. In combination with a gray mat the flat bands of the frame have a linear quality which is in keeping with the character of a drawing; at the same time the classic symmetry of the design emphasizes the spontaneity of the medium.

For this picture, which is handled in a traditional manner, an antique frame is just the thing. The familiarity of the scene and the directness of the technique have a warmth which is complemented by the mellowness of the frame.

◀ *The handling in this delightful picture creates a textural surface which the grain of the barnwood frame makes even more light and airy. The flat decorative quality is further enhanced by the frame's reverse design. In this case the silvery sheen of the weathered wood was a perfect foil for the cool blues and greens in the painting so we used it "as is" with no further treatment. The raised molding was toned with a coat of off-white vinyl paint.*

▲ *This highly textured sand painting on stretched burlap is lifted away from its surroundings, floating above the frame. The distressed finish of the frame naturally introduces the viewer to the creation.*

Tom Ballanger—Sunflower—Collection of Christiane and Hal Rogers

In a simple modification to the strip frame, we've added a ¼ inch (.6 cm) parting strip to the inside, creating equal steps down to the picture. The sharp shadow lines created accentuate the soft flowing lines of this lovely serigraph.

Sources

Because most of the items in our method of making and finishing picture frames are easily obtained, it is no longer necessary to buy and store large quantities of materials.

Most of the materials can be found in your local art-supply or hardware store, paint shop, lumber yard, or home-supply center. You will also find many of these items listed in the larger mail-order catalogs (many have special sections on picture framing) and in the classified section of your telephone directory.

Should you have any difficulty locating a particular item, your local merchant can often suggest an excellent substitute; if not, the following list of sources will be helpful.

ADHESIVES

Construction

Casein glue (Elmers—Weldwood—Sears)
Source: Hardware, paint store, art store

Mounting

Synthetic glue
Source: Art store
Source: Bookbinding supply

> Talas (Jade #403)
> 213 W. 35th St.
> New York, NY 10001

TOOLS

Construction

Lion Trimmer
Source: Pootatuck Corp.
Windsor, VT

Other hand tools
Source: Hardware or discount store
Source: Tool catalogs:

> Stanley Tools
> 195 Lake St.
> New Britain CT 06050

> Brookstone
> Peterborough NH 03458

Finishing

Rake (Paint scraper)
Source: Hardware or discount store

Gilder's tip
Source: Paint store, sign painter's supply

Mat and X-acto knife
Source: Art store, hardware, paint store

Straightedge
Source: Art store, paint store

Compass
Source: Art store

Glass Cutter
Source: Hardware, art store

Roller
Source: Art store, paint store

PAINTS

Thick "Vinyl" base or "Latex" base
Source: Paint store

LEAFS—POWDERS

Gold and metal leaf
Source: Paint store, art store, sign painter's supply

Powdered gold (Venus Bronzing Powder)
Source: Paint store, art store

MAT BOARD (Regular or acid-free)

Source: Art store

LINEN TAPE (Acid-free)

Source: Art store, frame shop

WAX (BUTCHERS)

Source: Hardware or paint store

LINEN

Source: Art store or
Utrecht Linens
111 4th Avenue
New York, NY 10003

Index